CONTENTS

OPPOSITE PAGE: Desert photographs should say "hot." By including the sun and underexposing, the photographer was able to oversaturate the colors, creating an almost purely graphic image that makes this desert scene seem otherworldly.

Thomas J. Abercrombie

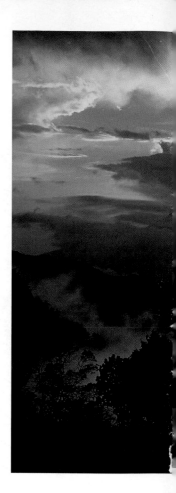

WE LIVE IN AMAZING TIMES. I can tell you what the peak of Mount Everest, the Black Forest, China's Gobi, the Dismal Swamp, and even the surface of the moon look like—despite the fact that I've never been to any of these places. And I can characterize them, too; I can tell you what they feel like. I can do this because I've seen good landscape photographs of them— photographs that convey both the literal look and the character of the scenes.

Every place—each mountain, forest, desert, or plain—has its own particular qualities and ambiance, its own personality. The job of the landscape photographer is to distill this feeling into visual elements and then find ways to capture and communicate it. Looking and thinking are the most important tools—as in any kind of photography, understanding your subject and deciding what you want to say about it are key to success. Then you must experiment—try different lenses and angles, hike to various vantage points, and often return to get the light that best enhances the mood. The successful result allows the viewer's eyes and heart to travel to the scene, to feel as the photographer felt. A good landscape photograph gives us a sense of place.

After our families, landscapes are probably our favorite subjects. But they are among the trickiest. A grand scene is not easily captured on a tiny piece of film. In this guide you will explore elements of thought, composition, light, and

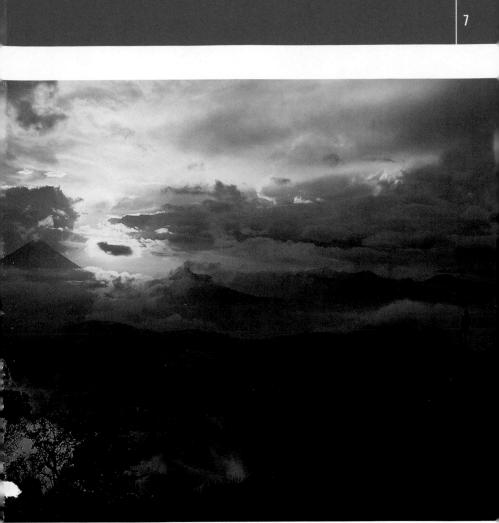

Joseph J. Scherschel

gear that go into making good landscape pho-
tographs as well as the what, when, and how of
shooting; get philosophical and practical tips
from three National Geographic photographers
whose images have brought us evocative
glimpses from around the globe; and be encour-
aged to make lots of pictures. Photography is
like playing the piano, golf, or any other skill.
The more you think about and do it, the more
accomplished you become. This book will be a
springboard for your own photographic explo-
rations of the world around you.

The quality of light
is one of the most
important aspects of
landscape photography.
Late sun backlights
mountains and fog
in this dramatic scene.
The small human
silhouette to the right
gives the scene both
scale and an active
sense of viewing.

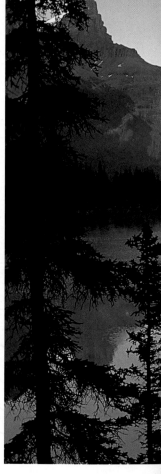

A Sense of Place

WE'VE ALL HAD THE EXPERIENCE: You're driving along through beautiful country and stop at every scenic overlook to make pictures you are sure will capture the grandeur of what you see. You get home, have the film processed, and… are disappointed. The images are flat, boring. All the elements that so enthralled you at the time are there, but not the feeling. Why?

When we look at a scene, our eyes travel over it and selectively focus on the elements we find appealing. Our field of vision encompasses a great deal of the scene, but our eyes and brains can ignore all except the most alluring details. Lenses and film can't do this by themselves—they need your help. Photographs are two-dimensional, so one element, the third dimension, is automatically eliminated from our representations of the real world. And, of course, when we are viewing a scene live, all our other senses add to the effect—the sound of rustling leaves, the smell of a newly-plowed field, the taste of salt air, or the feeling of a breeze on our cheek are all part of the experience. To convey a real sense of place, our landscape images need to evoke other senses as well as sight.

Focusing attention on a wooded islet and its reflection suggests the crisp air and pristine feel of a mountain lake. The tree at left and the leading lines on the right carry our eyes into the frame.

Stop, Look, and See

To capture a sense of place, you must first determine what made you stop. What is it

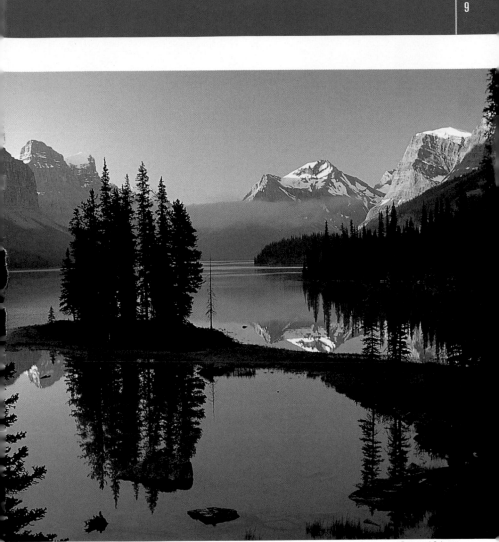

Raymond Gehman

about the scene that captured your attention and made you want to photograph it? Was it the distant mountaintop, the play of light on water, the color of autumn leaves, the big sky? Something in the scene spoke to you, and whatever it was should be the point of interest in the frame. Then look hard at the landscape in front of you. What other features are available that will help you focus attention on the point of interest? Perhaps there's a river or road

FOLLOWING PAGES: The barrenness of rocky hills, enhanced by late, raking light and dark sky, is emphasized by featuring a lone tree, brilliantly lit. Use of the rule of thirds and great depth of field reinforce the message.

Chris Johns

winding its way toward a mountain, an old stone wall slicing through a field, or a flaming red tree standing alone in a grove of yellow ones. You will probably have to hike around a bit to incorporate these elements and to find the right angle. A move of only a few degrees to the right or left, or up or down, can make a dramatic difference in the image. You will need to work at finding the best angle. Rarely are great images made from scenic overlooks—they are usually sited for the convenience of road builders, not photographers.

Also look at how the light is falling on your subject and think about where it would be earlier or later in the day. You may want to come back at a different time, or even in a different season, to get the effect you seek. We will talk about leading lines, framing, and other compositional techniques as well as light and weather in subsequent chapters. Just remember: You have to be able to see the scene before you can photograph it.

Think in Adjectives

Once you have decided what it is about a scene that appeals to you, consider the place's character. Think of adjectives you would use to describe the place to a friend: a majestic oak tree, a desolate lighthouse, a lush garden, a wide-open prairie, etc. Then look for ways to emphasize the feeling you have decided is appropriate—the physical (photographable) elements and the quality of light that will help you convey the spirit of the place.

For example: A lighthouse does not come across as very desolate if you shoot it in bright daylight and it fills the entire frame—it might be beautiful, but there would be no sense of its physical setting. Use the ocean and the shoreline

George F. Mobley

or rocky promontory on which it stands to capture its sense of "beacon." Try to shoot it around dawn or dusk, when the film can record its light, and preferably in fog or with a stormy sea sending spray up around it. Such an image will look quite different from one of the same lighthouse shot on a sunny afternoon, and will say much

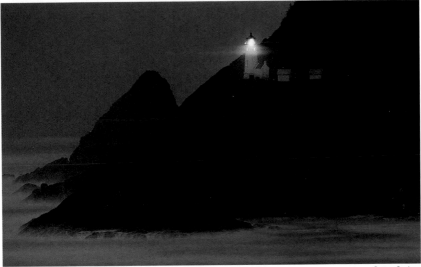

Cotton Coulson

Time of day and weather greatly affect the quality of scenic photography. To accentuate a lighthouse, shoot it at dusk. In the image above, the photographer has included enough of the rocky shoreline to convey the dangers the lighthouse advertises. Using a telephoto lens to photograph the foggy forest opposite compressed the scene into a moody graphic.

more about the idea of "lighthouse." Photographs need to be both of and about a subject.

Photographing New Places

Research is the key to photographing new places. Visit libraries and bookstores to look at travel guides and picture books about the place. Go

online to see if travel magazines have relevant stories in their archives and to visit the place's tourism Web site. When you arrive, look at postcards and brochures. Talk to taxi drivers and folks who work in the hotel. Doing this will give you an idea of what the area has to offer and will save you a lot of time. It's not that you want to copy images that other photographers have made, but seeing how they treated a place will give you ideas of your own.

Time is the most important investment you can make in getting good landscape pictures. When you arrive in a place you have never visited before, do all the things mentioned above. Then spend quite a bit of time scouting—driving or hiking to various locations, finding different vantage points. Carry a compass so that you can determine where the sun will rise and set, and imagine how the place would look in different lights. This can take some practice, because you also have to look at where the light will not be falling. If you're photographing a canyon, for example, you might discover that the west wall will be beautifully lit in the early morning. But if the canyon is deep, the east wall will be in such complete shadow that the film will be capable of rendering it only as a great black blob. Unless this is the effect you want, either modify your composition, shoot it later in the day, or plan to return on an overcast day, when both sides will be visible to the film.

Look at the scene through different lenses, from wide-angle to telephoto, and think about

> **Tip**
>
> Visualize your photograph. Create the image in your mind the way a painter would create it on a canvas. Then think of the time, light, and composition that will translate what you envision onto the film.

Always view your subject from more than one vantage point. The top image of the walled town of Lo Manthang in Nepal was fine, but by moving up a hill I was able to show more of the town's layout as well as snow-capped peaks hidden by the looming hills. Including the mountains gave the image a better sense of the town's setting.

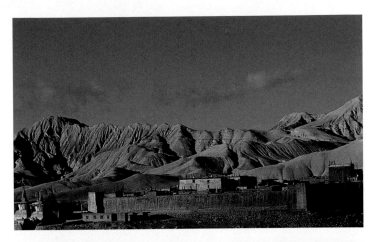

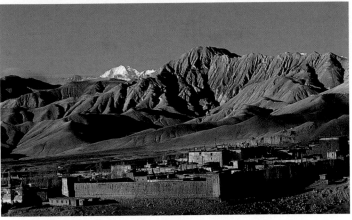

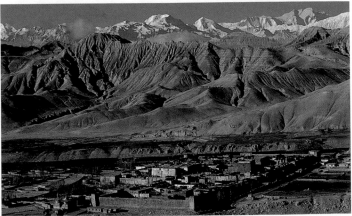

Robert Caputo (all)

how each one affects it. Do you want to compress the scene with a long lens, or widen it with a short one? And look for foreground and other compositional elements that might enhance the image. Then make a shooting schedule of where you want to be at different times and what equipment you will need: Predawn photographs usually require a tripod, for example. Check the forecast and make alternate plans in case the weather turns lousy.

It is often a good idea to get up very early so that you can be on site and ready when the first light begins to illuminate the sky. Try to plan the predawn, sunrise, and early morning locations near one another so you don't waste valuable time getting from one place to the next—the gorgeous light does not last long. Early in the morning and late in the afternoon, sunlight is warmer in tone (more red) than it is at midday, something we will discuss in When to Shoot under Time of Day. And it is much more fruitful to spend time on one or two locations than to race around. Remember that a great shot of one place beats several mediocre ones of many.

Such an approach allows you to be creative. Once you have recorded the image you were thinking about, try something different— climb a tree, use a flower or some other object in the foreground, try another lens or a slow shutter speed. Play with the subject and your gear. Have fun. You may be surprised at the results, and you will often capture something more than what postcards show—something that is quite personal.

An Important Exercise

To really see how different light, different angles, and different composition affect an

image, practice the following exercise: Find a place near your home that you find attractive and interesting—it might be a garden, a statue in a park, a stand of trees, or anything else that is a good subject for a landscape picture and is near enough that you can't find excuses for not going. Think about the place and what feeling you want your images to convey about it. Then photograph it at different times of day in various weather—at dawn, early morning, noon, late afternoon, and dusk on sunny, cloudy, rainy, and foggy days. Also shoot it in many seasons to see how they affect the mood of the photographs. Experiment with lenses and angles. You will end up with a lot of images, but when you lay them out side by side, you will quickly see which ones work and which don't. And, since you know what the conditions were when you made each image, you will know why. You can apply the knowledge you get from this exercise to any situation you come across.

Study the work of other photographers. Painters pore over the works of the masters to hone their own skills, and we can do the same. If you want to shoot deserts, look at books by photographers who have worked there. When you encounter an image that strikes you, think: How has the photographer framed the image? What is the point of interest? What time of day and in what season was it shot? Where was the camera? Was there a little or a lot of depth of field? There is always a reason that an image catches your eye, and that reason is decipherable.

Seeing and Thinking

The two most important elements in any kind of photography are seeing and thinking. There is usually no great rush when you are making

> **Tip**
>
> After you have made the image you had in mind, walk or drive closer to the subject and try again. Proximity to the subject will make it strike you in a different way.

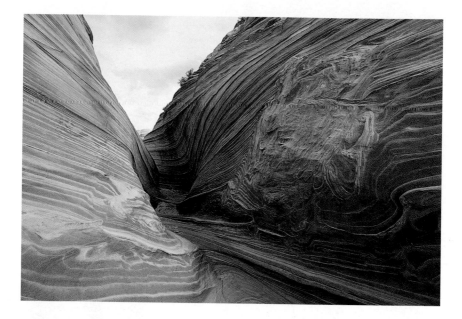

Tip

Cut a rectangular hole with the same proportions as your film format in a piece of cardboard and carry it with you. Look at a scene through the hole to see if it is a picture you want. Holding the cardboard close to your eye will duplicate the effect of a wide-angle lens; holding it farther away will duplicate the effect of a telephoto.

landscape pictures, so when you hold your camera up to your eye, pause a moment. Is what you see in the little rectangle something you would like to put on a page of a magazine, in your photo album, or hang on the wall of your living room? Imagine that you are going to show this shot to a friend who has never seen this place. Does what you see capture the look and spirit of the scene? If not, don't press the button. What would improve it—different light, a different angle, coming back later, lying down? All places are photogenic. It is our job to figure out how.

In the following chapters we will explore aesthetic and technical ways to compose and light your photographs, ways to capture the feeling you have about a place on film. That feeling is the most important element in making good photographs—something in nature moved you, made you want to record it. Think of these techniques as tools you can use as you pursue your own personal vision of our world.

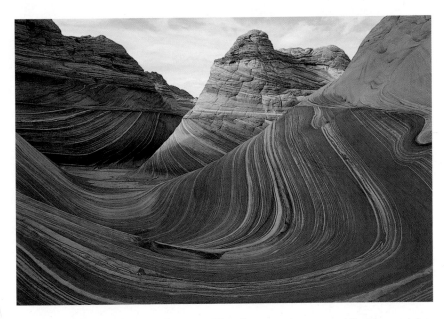

Explore with your feet and your eyes. The photographer sensed that the undulating striations of a canyon would yield an interesting image, and he worked the scene over. A wide-angle lens and great depth of field in both top and bottom shots captured the contortions of the rocks as well as an idea of their extent.

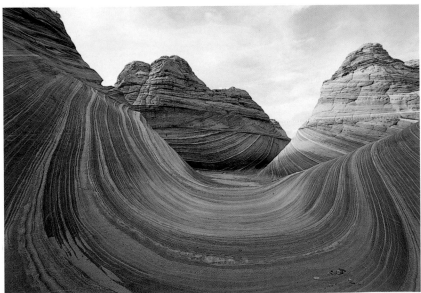

James P. Blair (all)

The Three Elements of Photography

PHOTOGRAPHY CONSISTS OF THREE ELEMENTS: the subject, technical manipulations that record the image on film, and the aesthetics of composition and light. Many people find that they are drawn to a particular type of subject—landscapes, people, or wildlife, for example. The technical elements, because they are logical, are, with practice, fairly easy to learn—choice of film and lens, how to set the right combination of f-stop and shutter speed for different situations and effects, how to use fill flash, etc. Aesthetic choices are more complicated because they pertain to seeing—to personal vision and preferences.

There is no wrong way to make a photograph. But it's easy to see that some work is better than others. Better photographs are the ones in which the composition—the aesthetics—of the image works with the subject to provide information clearly or to evoke a sentiment.

If the goal of photography is to communicate a fact or a feeling (or both), then you want your images to do that as meaningfully as possible. It's like writing a sentence. There are an infinite number of ways to say the same thing, but the best and most moving way communicates with your reader powerfully and clearly. Having a large vocabulary and knowing the rules of grammar help us express ourselves with words. Learning about photographic composition is like increasing your

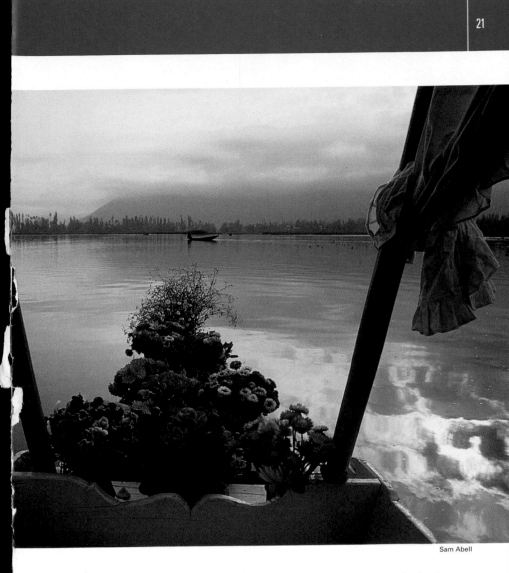

Sam Abell

vocabulary and grammar of visual representation.

In this chapter we will explore compositional techniques that make your photographs and what you want to communicate more effective. These techniques are things to consider and to watch for when you are in the field making images. These methods are not hard and fast rules: They are tools to expand your visual repertoire, which can help you express your vision. Great painters do not start off great. They begin by studying other

Rules can be broken. The diagonal lines and the triangle thrusting outward carry the eye into this scene, a dramatic and effective use of the technique of leading lines. Centering the flowers and distant boat, something we usually avoid, in this case is effective.

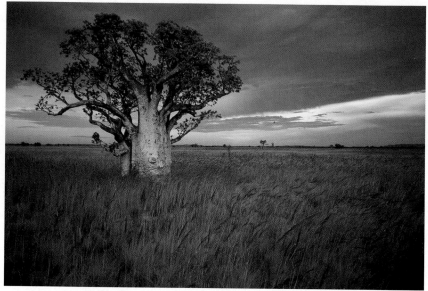

Sam Abell (both)

The baobab tree is obviously the point of interest in these images, and it stands out equally in both. But the image above, which conforms to the rule of thirds, works less well. Using the usually taboo bull's-eye composition, the photographer enhanced the sense of awe that this tree could prosper alone on the plains. Every situation is unique; determine what technique is most appropriate.

painters, by working with their materials— paint and canvas types, etc.—until they understand them, and by drawing from nature, whether still lifes, figures, or landscapes. Musicians start with scales and simple tunes. After mastering these basics, they can move on toward their own personal expressions. You must know the rules before you can break them. Experiment with the techniques discussed here, and then study the results to see how they affect your image-making.

Point of Interest

Every photograph has a point of interest—it's

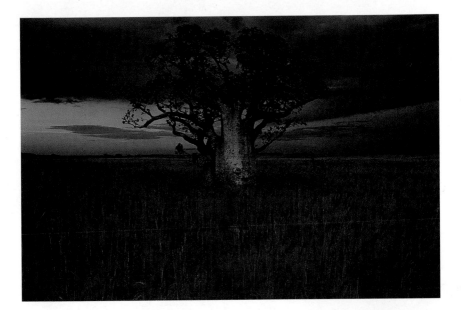

whatever spoke to you, whatever made you turn your camera in its direction. But you have to make sure that it is clear to the viewer just what that point of interest is. We look at photographs much the same way that we read a page of text—in our culture from left to right, from top to bottom. The lines of words carry our eyes across the page. In visual representations, we do not want the viewer's eyes to roam aimlessly around within the frame. Rather, we want to find ways to guide them to the point of interest in the image. We want the viewer to focus on it just as we have focused our lens. This concept is what composition is all about.

The vast majority of photographs don't work for the simple reason that the photographer was not close enough to the subject. It's hard for a subject to have much impact if you can just barely see it in the frame. One of the primary rules of good photography is "get closer." If you cannot move closer physically, use a longer lens.

Always think about what you are trying to say with an image. If you are making a photograph of an isolated farmhouse on the prairie, it must be big enough that people can see what it is. But it should not fill so much of the frame that the viewer loses a sense of its environment and the feeling of isolation. Experiment with different lenses and locations until you have found the right balance.

Avoid the Bull's-Eye

The bull's-eye composition is the second big mistake many photographers make. Avoid placing the point of interest in the center of the frame. Such images usually don't work because our eyes find them boring; they seem too static. Our eyes go directly to the center of such an image, with no interesting journey taking us there. We subconsciously perceive nothing else of interest in the frame, so we move on.

We've all seen (and most of us have made) pictures of a person whose head is smack dab in the middle of the frame, whose feet are cut off, or who is surrounded by empty space. Such pictures rarely tell us anything about the person or his environment. Our eyes find off-center subjects more pleasing and more dynamic, and we are willing to look at them longer.

When you are photographing a landscape, take some time to look through the viewfinder. See how the isolated farmhouse on the prairie looks with the farmhouse in the center of the frame. Then move the house to the right and to the left, and up and down. Which shot appeals to you the most? That is your picture. The following sections will help you get a feel for different compositional techniques and how they can help you focus your image on the point of interest.

<div style="border:1px solid; padding:5px">

Tip

To get an idea of how effective off-center composition is, glance over a rack of fashion magazine covers. You will notice that a model's head is usually placed in the upper right quadrant of the frame, and often turned slightly into it, so that our eyes travel first to the face and then to the left and down. Seldom are the models placed dead center.

</div>

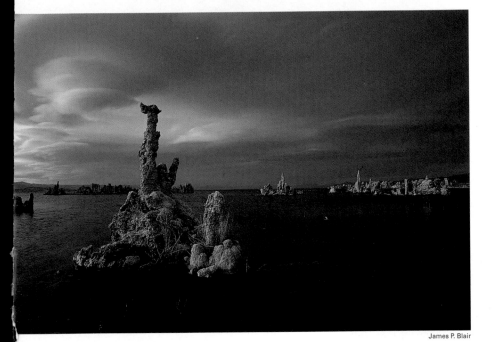

James P. Blair

The Rule of Thirds

When you complete the exercise with the farm-house on the prairie discussed previously, you will probably find that the most pleasing com-position places the building about a third of the way into the picture and a third of the way from the bottom or top. This placement reflects the rule of thirds, a convention established long ago by painters that, like any method that works well, has been popular ever since. The rule is exactly what it says: Imagine that your viewfinder has lines dividing the space into three horizontal and three vertical fields of nine equal-size rectangles. To use the rule of thirds, place your subject at one of the "sweet spots" where a vertical and a horizontal line intersect. Our eyes find compositions with the subject placed like this both pleasing and dynamic.

By placing a strong vertical one third of the way into the frame and using great depth of field, the photographer has conveyed a mood about this scene as well as information about the makeup of the columns and their extent. When you view a scene, pan the cam-era around as you look through the viewfinder to find the composition that pleases you.

It will usually be pretty clear which one of the intersections to use as the focus of your image: Whatever else is in the frame will either help or detract from the image. In the farmhouse example, look at the sky and at the prairie. If a big sky gives more of the feeling you want, put the farmhouse in the lower third of the viewfinder. If the prairie is more powerful, put the farmhouse in the top. Deciding to place the focus to the left or the right usually depends on secondary elements within the frame, and whether they add or detract.

Foreground Elements and Depth of Field

Another common problem with landscape pictures is that there is often too much empty space in the foreground. The prairie surrounding the farmhouse in our example adds to the feeling of the picture, but many landscapes contain empty space that serves no purpose. Everything in your frame needs to say something about the place. If you cannot get closer to your subject to avoid empty space, think about using elements in the foreground that will make use of that space by adding depth to your two-dimensional image.

Look around for something that fits in with your idea for the photograph—flowers, a pond, a tree, a boulder, a haystack, for example. The element can be something as simple as the scree on a mountainside or the sloping sand of a dune, as long as it says something about the landscape. Find an angle that uses this element to fill the space and to help lead the eye to the main subject—the point of interest. You may want to crouch or lie down to get the right perspective.

Wide-angle lenses are the ones most appropriate for shooting landscapes with objects in the foreground. Wide-angle lenses offer great depth of field, which is necessary in order to

Sharp focus is crucial to this image of footprints crossing a sand dune. A wide-angle lens and great depth of field allow us to see everything clearly and reinforce the feeling of stark brilliance we associate with deserts. Including the sun further enhances the feeling, as do the long shadows it casts.

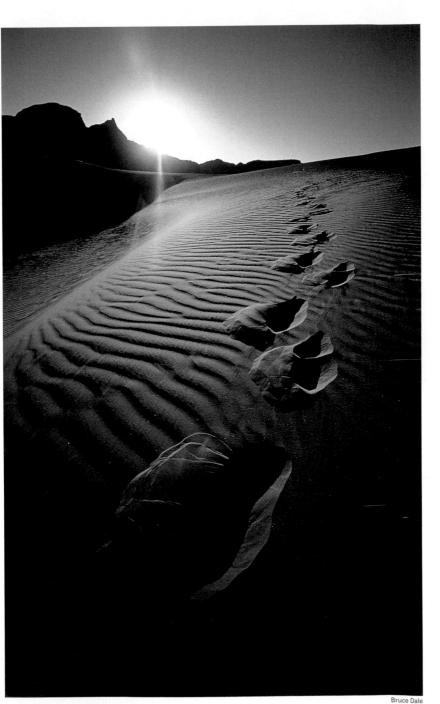

Bruce Dale

have both the foreground and the main subject in focus. How much depth of field is necessary depends upon the size of the object in the foreground and how close to it you are. If it is something quite small, like a flower, you will have to get very close to it for it to be readable and to fill up much of the frame. To get enough depth of field, you will probably need a very small f-stop (f/16 or f/22) and therefore a very slow shutter speed. Use a tripod for anything under 1/60 of a second, and be sure that the wind is not blowing and causing the flower to blur. Some single lens reflex cameras have depth of field preview buttons. If your camera has a depth of field preview button or your lens has a depth of field scale, check to make sure that both the foreground and background of the shot are in focus.

Remember: It is true that the wider the lens, the greater the depth of field; it also holds true that the wider the view, the smaller the objects in the background. You don't necessarily want to be so close to a flower with such a wide lens that the mountaintop you're shooting recedes to a tiny speck. Always remember what your point of interest is, and use other elements to reinforce it.

The Sky

The sky can be an important element in landscapes, either as the main subject or as something that enhances the mood you are after. As with anything else that is in the frame, you should look carefully at the sky and determine if it warrants much space or should be minimized.

In our farmhouse on the prairie example, a big sky may reinforce the feeling of isolation. If it's a bright blue sky with a puffy white cloud or two, place the horizon along the imaginary line at the bottom third of the frame. If it is a dull

> **Tip**
>
> Take care in the placement of foreground elements. They should not obscure or detract from what your photograph is really about.

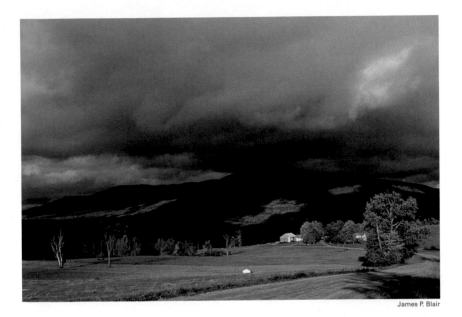

James P. Blair

white sky, you will probably want to minimize it.

Dramatic skies enhance the mood of land-scape pictures, so always be on the lookout for them. Roiling storm clouds, a shaft of sunlight piercing a dark sky, a rainbow—all are photo-graphic elements you can use. Again, study the work of landscape photographers and painters to see how they have treated the sky, and then keep those images in mind when you are in the field.

Be careful metering if you are including a lot of white sky in the frame. In-camera meters are easily fooled into underexposing with so much brightness. Take a reading from a gray card or something of equivalent value, and then either set the exposure manually or, if you are using an auto mode, slightly depress the shutter button to hold that exposure while you reframe. You can also use a polarizing filter to deepen the blue of the sky and increase its contrast with white clouds. A blue color-graduated or graduated natural density fil-ter can add depth and color to a dull sky.

The sky can be just as important as any other element in your images, so look closely and decide how you want to treat it. Think, for example, how different the above image would look and feel if it had been made when the sky was clear and blue. Take advantage of dramatic skies.

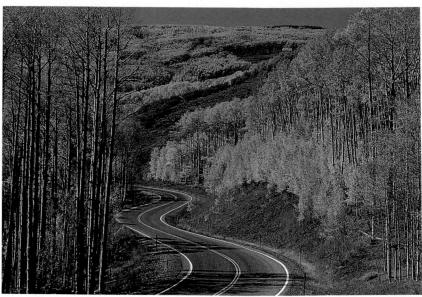

Bruce Dale

The classic S-curve of a road winding into a forest (above) carries the eye into the scene. Be on the lookout for leading lines, whether natural or man-made, such as the cultivated rows that sweep into the frame below. In both images the photographers have used great depth of field and let the lines do the work.

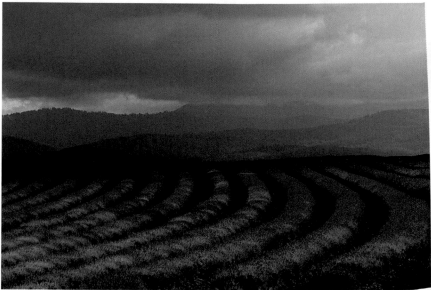

Sam Abell

Leading Lines

As with foreground elements, leading lines are very useful to give a three-dimensional quality to our two-dimensional images. When used properly, leading lines carry the viewer's eyes into the frame, leading them to the point of interest. Because receding lines seem to converge in two-dimensional images, a stream or road seems wider in the foreground than in the distance, and our eyes will follow it into the picture.

Nature presents all sorts of leading lines—the most obvious are rivers and streams, mountain or sand dune ridges, and tree lines. But also keep an eye out for man-made ones such as roads, fences, and walls. And look for more subtle ones—compression lines in rocks, wind-carved lines in sand, erosion channels, fallen trees, and the like.

In our prairie example, perhaps there is a driveway snaking its way to the farmhouse, or a fence slicing through the wheat, or the line between a harvested field and one that is still uncut. Move around until you have found an angle that uses one of these to lead the eye to the farmhouse.

Think about depth of field when you are composing with leading lines. If the line begins at the bottom of the frame, you will want to make sure that both it and the main subject are in focus. You may have to use a tripod if the aperture that gives you that depth of field requires a long shutter speed.

Framing

Another useful foreground technique is framing, using something in nature that frames part or all of your main subject. It can be just about anything—a branch with autumn leaves, the mouth of a cave, or a weathered tree trunk.

> **Tip**
>
> If shafts of sunlight are penetrating the clouds, be careful not to take your reading from them because they will fool the meter.

FOLLOWING PAGES: Using the sweep of rock at a cave entrance as a frame gives this image depth and an active sense of looking. In this rather tricky lighting situation, the photographer has exposed for the fully lit wall on the left, letting the upper part of the frame and the distant valley fall into shadow.

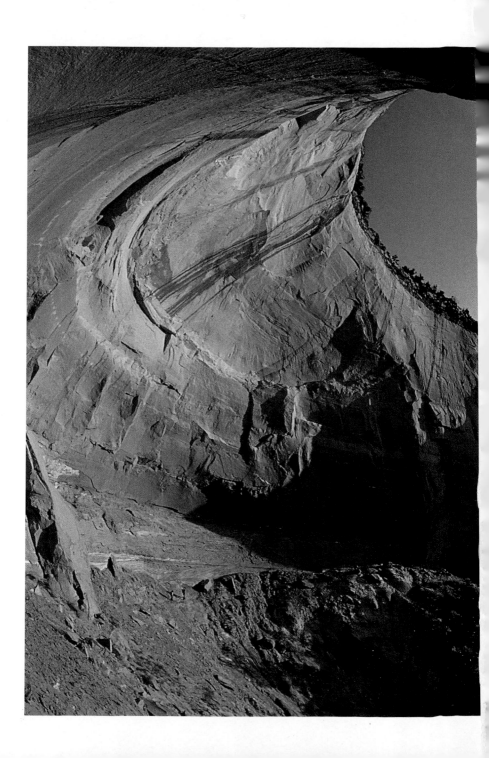

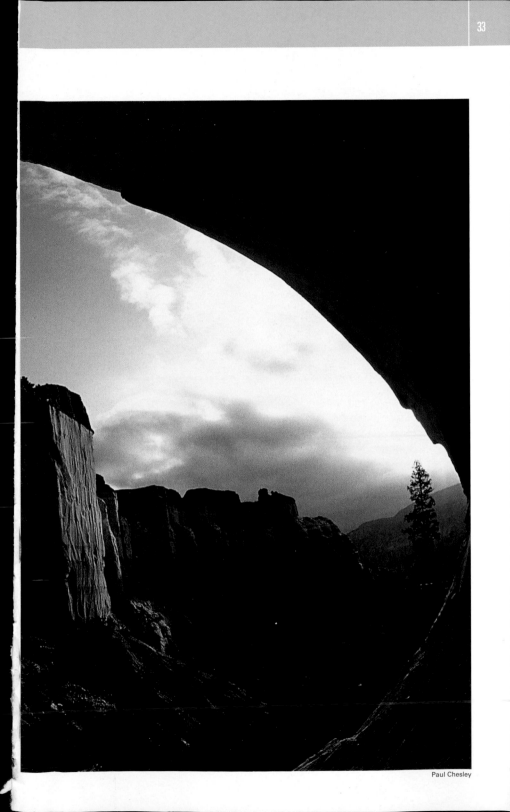

Paul Chesley

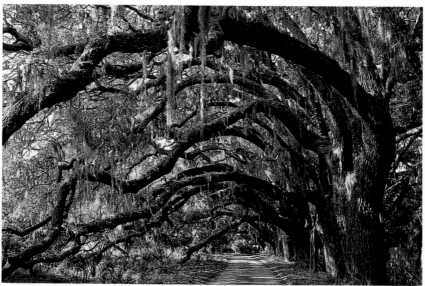

Maria Stenzel

Combining framing and pattern, the photographer of the scene above used the repeating shapes of the overhanging branches to carry our eyes into the image and down the road they frame. Isolating the dead wood and shoots emerging from the water (below right) creates an image of almost pure pattern.

The framing object may be in different light from your main subject, so meter carefully. Take the reading of the light falling on your subject, and think about how the frame will look. It may be that you want it to be in silhouette, but if not you may want to use fill-in flash to get some detail in it. It is a good idea to make several exposures in situations like this, reducing the power of the flash in thirds from full strength to a stop and a third under. And be careful of depth of field. Some framing objects look best if they are sharp, while others are more effective if they are out of focus. Think about how different apertures will make the scene look.

The framing objects should be appropriate to your subject and enhance the overall image by

adding another element of the environment, either by harmony or by contrast. They also help carry the viewer's eyes toward the subject, since they give an active sense of peering through a window of some sort. In this respect using framing within the image is akin to choosing the frame for a painting. Next time you go to a museum, notice the frames around various works and consider how they would look with different ones—a Rembrandt would not feel the same surrounded by narrow metal.

Patterns

Nature is full of patterns, some grand, some intimate. Always look for them as you explore locations for photographs—the repetition of patterns, like the rule of thirds and leading lines, makes an image more dynamic and interesting. The pattern may be columns of tree trunks, wavy lines on a

Stephen St.John

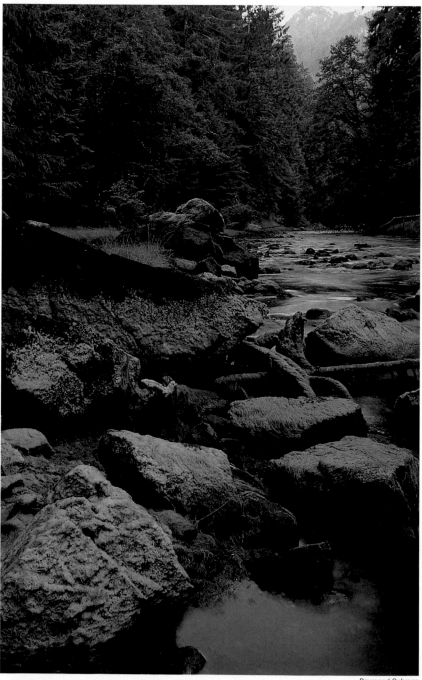

Raymond Gehman

sand dune, icicles hanging from a bough, or squares of agricultural land seen from above.

A pattern can become the subject of the photograph, or it can reinforce the point of interest by leading to or framing the subject. If the pattern is the subject, choose a lens that accentuates the repetition. In the case of tree trunks, for example, you might use a long lens to compress them; with an aerial of fields you might choose a lens wide enough to show a lot of squares. Icicles on a bough might make a nice subject, especially if sunlight from behind refracts into a spectrum of colors. Icicles might also make a good frame along the top of a winter image.

Scale: Using People and Animals

When we look at landscape pictures, our minds make a series of mental adjustments based on previous experience. We've seen so many pictures of the Tetons, the Grand Canyon, and Old Faithful, for example, that we can easily work out their size. It's more difficult to estimate the size of unfamiliar places, so we often rely on some element we can quickly recognize—frequently a person or an animal—to give the image a sense of scale. A human figure next to an oak lets us know just how big it is; a cow informs us of the extent of its pasture.

These figures can be used in two ways: as foreground elements or close to the main subject. If you use them in the foreground, treat them as you would any other element—consider placement and depth of field. A person standing to the side and gazing into a valley adds depth to n image as well as a sense of scale. If you are ographing a cliff, you might wait until some pass. To communicate the enormity of the k away and use a telephoto lens. Let the

Tip

Framing can be very helpful when you cannot get close to your subject and have to somehow deal with empty space, either in the foreground or in the sky.

OPPOSITE: Similar shapes of mossy rocks in the foreground create a pattern our eyes follow into this frame. Note the composition: The closest rock is at the bottom left; the others tend to the right, leading to the stream.

FOLLOWING PAGES: Late light and the repetitive shapes of sunlit and dark ridges lend depth to this image. Recognizable elements like the sailboats give scale to a photograph.

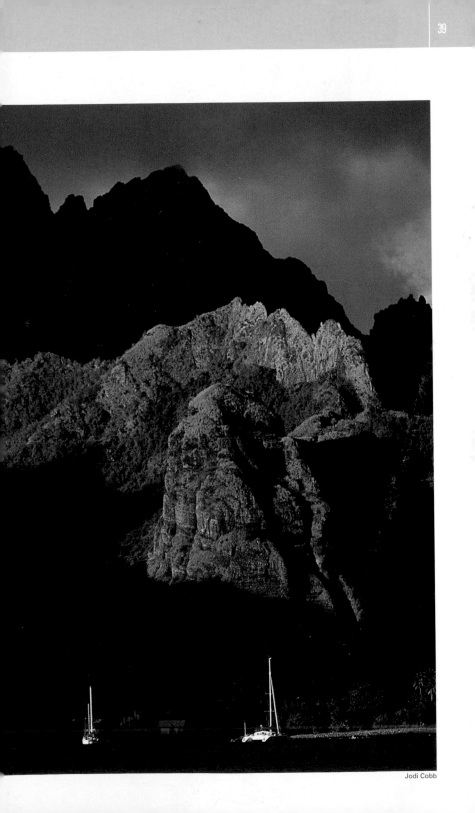

Jodi Cobb

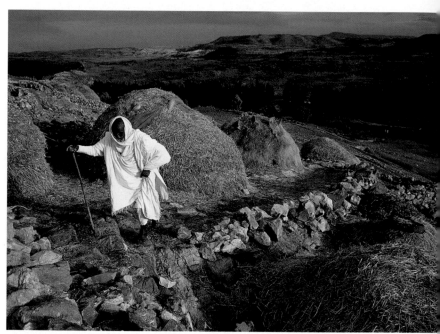

Robert Caputo

The shrouded traveler lends this image scale. Without him we would have no idea how big the mounds of harvested grain are. The leading lines of stone and the mounds descending the hill carry our eyes down into the valley.

cliff face fill the frame, cutting it off just below the top and including the figures at the bottom. It will seem to loom over them.

Anything of immediately recognizable size can give a sense of scale, but be sure the object fits the theme of your photograph. A rusted windmill might be appropriate on the prairie.

Negative Space

Just because some space in the frame is empty does not mean it is wasted. The concept of negative space refers to using such emptiness to reinforce the theme of an image.

Using negative space is particularly appropriate when communicating a sense of isolation or loneliness—a single plant in the desert, or a rock jutting from the sea, for example. Think of the empty space as an object, like any other element, and then think about its place-

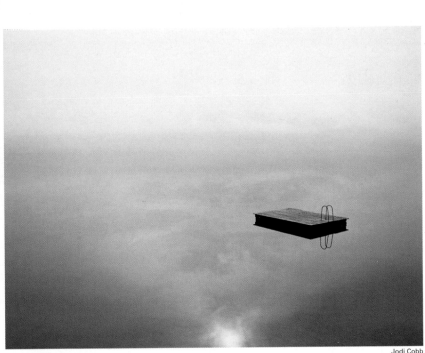

Jodi Cobb

ment. You want to keep the scale of it and the subject in the proper balance that reinforces your message.

Eliminating Unwanted Elements

Everything you see in the viewfinder will be part of the image and should have a reason for being there. Look carefully. If you see something that seems out of place, change angle or location. If an item doesn't help the image, get rid of it.

The most common unwanted elements in landscape pictures are power and phone lines, poles, and distant buildings. Also look out for more subtle ones—a branch in the frame, a piece of litter. It pays to study the image in the viewfinder carefully. If you don't notice small things when you make the image, you probably will when you get the film back. Viewers almost certainly will.

Empty space is not always wasted. The negative space of the lake in the above shot conveys calm. The placement of the swim raft conforms to the rule of thirds.

Tip

If you are with friends, don't be shy about using them in images to get a sense of scale. But remember that the photos are of the place, not the people.

JIM BLAIR
Landscapes With a Purpose

JAMES BLAIR GREW UP admiring the work of Lewis Hine, Jacob Riis, and other social-documentary photographers. In 1951 Blair jumped at the chance to participate in a project documenting the changing face of his native Pittsburgh, and he later photographed refugees fleeing Vietnam and Hungary. After joining the staff of the National Geographic Society in 1962, Jim continued to photograph stories he thought important, including an award-winning piece on South Africa. By the time he retired in 1994, Jim had published 47 stories in the NATIONAL GEOGRAPHIC, numerous pieces for Geographic books, and had won many awards.

Jim's use of photography to heighten awareness was not limited to his coverages of people. In addition to compelling landscape images made for the Magazine, he photographed *Our Threatened Inheritance,* a National Geographic volume about America's federal lands.

"Landscape photography is not just about making pretty pictures," Jim says. "It can also serve a purpose. Your job is to find and communicate the emotion that will move your

Jim Blair's eye for landscape images and his heart for conservation have taken him all across America and beyond (left).

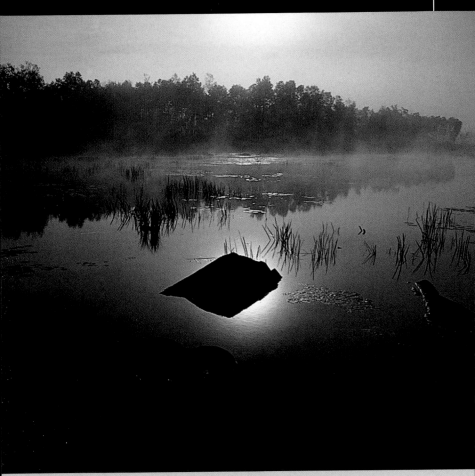

Blair waited patiently for just the right light—when the sun's reflection was masked—to shoot the scene above. He wants viewers of his work to care enough about the natural world to want to save it, so he works hard at getting evocative images.

viewer to care about a place. The images in *Our Threatened Inheritance,* for example, did a lot to help preserve the federal estate—the national parks, refuges, and other lands that are in our collective care."

Like other Geographic photographers, Jim does a lot of research before photographing a new place. But to him that is only the beginning. "Research points you in the right direction," he maintains, "but you really have to work to get a good image. If you go to Yellowstone or any place that has been much photographed, you have to find a new picture. One way to do that is to go at the so-called "wrong" time of year, such

as Yellowstone in winter. You get pictures of
familiar places that are different from what peo-
ple have seen before.

"Even if you are in a place at the same time as
everyone else, look for ways to portray it differ-
ently, to avoid the cliché. For example, just about
everybody who has visited El Capitan has the
same picture of it—the best place to shoot it is
from the end of the parking lot late in the day.
Well, of course you are going to make that pic-
ture—it's the best one for a reason—and I did,
too. But then I got out a 20mm lens and started
working it, and I got something quite good and
different. Experimenting like this is one of the
keys to making a good photograph. Explore a
place with different lenses. Move around to dif-
ferent vantage points. As with any endeavor, you
have to be willing to take chances—both physi-
cal and intellectual—if you want a reward. It
costs some time and some film, but it is certainly
the best way to learn."

Collaboration with picture editors is also
important to Jim, especially when tackling a
subject as vast as all the federal lands in the
United States. In addition to helping set a course
for the coverage and with research, picture edi-
tors are a good proxy for the reader's eyes. "John
Agnone, the picture editor of *Our Threatened
Inheritance*, helped me get over the hump in
what was a huge undertaking. He looked at the
first take I brought in and said, 'If you keep get-
ting images like this, we have a book.'

"Landscape photography is a lot of work. You
have to get up early and stay out late—whether
the light is good or not—because you never
know what the world will present to your cam-
era. If this is your passion, it is time well spent.
Luck is of course important, but the old saying is
true: You make your own luck. You have to stay

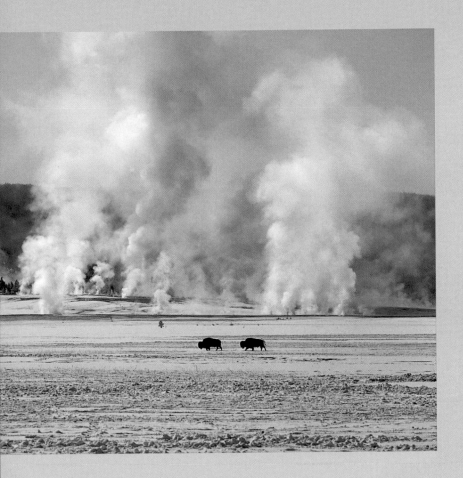

One problem for photographers is to get different images of much photographed places. In the shot above Blair solved this dilemma by going to Yellowstone National Park in winter, a time when few tourists visit the area, and got this unique and compelling landscape.

out long enough so that it's more on your side than not—to explore, to experiment. But that's one of the great joys of landscape photography—the excuse to spend a lot of time out in nature. I love sitting on the top of a mountain with nothing more to do than think about the scene and wait for the light."

Like other pros, Jim owns a lot of gear, but he concentrates on the aesthetics rather than the equipment. "A good landscape picture is one in which the sense of place comes through the two-dimensional surface of the printed page and reaches out to the viewer. This has very little to

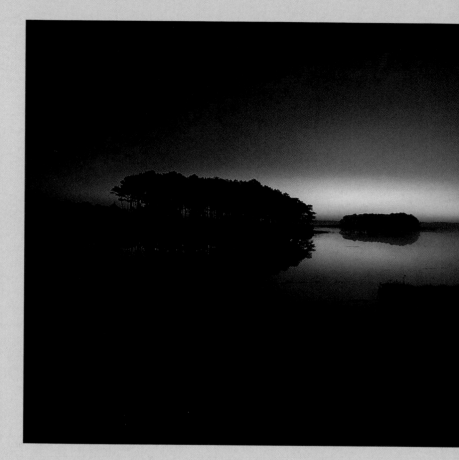

The glow of the below-the-horizon sun illuminates both the sky and the water in this serene image. By bracketing exposure, Blair was able to capture just the right balance of light and darkness.

do with technique, though of course you need to know what your tools can do. Most important is that you have focused all your energies in looking for that moment when the image of the landscape is right. You never know when this is going to happen—it can be after 30 seconds or after 2 days—so you always have to be alert. The payoff is tremendous: You're out there, you're waiting for the light, you're experiencing the place and anticipating, and then there's the moment of sheer bliss when it all comes together. All the time you invested pays off—you were there, you were ready, and you got it."

Jim is very careful with exposures, using graduated neutral density filters or whatever else might be required to allow his film to capture the tonal range and feeling of the places he photographs. "Bracketing is very important," he says, "but it is not just to ensure that you get the right exposure. It is really about aesthetics. Your only opportunity to control the image chromatically is with exposure, and by bracketing you can get the film to look most closely like what you saw."

Jim still gets up early, looks carefully, and makes photographs for personal work and a variety of clients. He still believes that photographs can serve a purpose, and his images continue to reflect that belief.

Blair's Photo Tips

- Show your pictures to other people. And listen to their reactions to them. You will learn from their comments whether or not the images work and get an idea of how they might work better.

- Get your camera set up on a solid tripod and use a remote release so you can concentrate on the scene and control the camera without having to touch it.

- Landscape photography can take you to places that are difficult to get out of, so make sure that somebody knows where you are.

- Carry a graduated neutral density filter for situations in which you need to get bright areas (usually the sky) and darker areas (like the land) in balance.

- It is all about light. Watch carefully and be willing to wait. When the light really strikes you, it will strike the photograph, too.

- Use your landscape photographs to make people care about the land. You can help save it.

Camera Formats

Most professional photographers use 35mm
cameras, but specialists, including landscape
photographers, often use a larger format because
the image quality, especially in large prints, is
better. The camera format you choose for land-
scape photography depends in large part on
what you intend to do with your photographs,
how willing you are to lug equipment around,
and how much money you are willing to invest.
Each type has advantages and disadvantages.
You must weigh them against your own needs to
determine which type is best suited to your
work. And always remember that it's not the
camera that makes the photograph, it's you.

 Compact (point-and-shoot) cameras are not
really suited to serious landscape photography.
Advanced Photo System (APS) cameras have a
panoramic setting that is useful for landscapes,
but the small image size, about 40 percent
smaller than 35mm film, limits good quality
prints to no larger than 8x10 inches. The full-
featured APS cameras are not much smaller than
their 35mm counterparts, and most profession-
als feel it is not worth giving up the image qual-
ity of larger film.

 If you are going family camping and don't
want to carry anything more than a compact
camera, an APS is a good choice because it offers
more versatility than the more common 35mm

Robert Caputo

point-and-shoots. But if you want to do more serious work, consider a larger format camera.

35mm Rangefinder Cameras

Some 35mm rangefinder cameras offer superb optics, small size, and quiet operation—attributes that make them popular with photojournalists and travel photographers, who want to make images of people in an unobtrusive way. For landscape photography, though, 35mm

Use a lens that is appropriate to your message. By shooting at dusk and compressing the hills with a telephoto, I was able to convey the mood and mystery of Africa's Great Rift Valley.

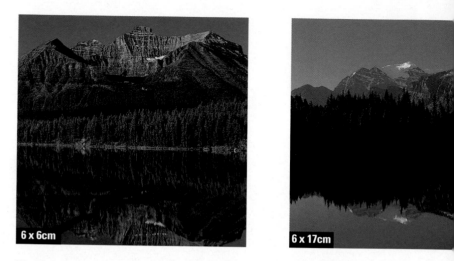

These four images, from 6x17cm panoramic to 35mm, show the relative sizes of some common film formats. The larger the transparency (or negative), the finer the relative grain and therefore detail, which is important if you are making large prints. But remember that larger formats mean bigger gear, too.

rangefinders are not ideal: The photographer does not see through the same lens that the film does, which makes extreme close-up framing difficult. You cannot check depth of field or see the effects of polarizing filters. There are no long telephoto or close-focusing lenses available.

35mm SLR Cameras

The 35mm single lens reflex (SLR) camera is far and away the most popular choice of serious amateur and professional photographers. The cameras and accessories are small enough to be easily portable, and they offer a wide range of lenses, electronic flashes, and other add-ons, as well as a range of prices from inexpensive to very dear. The 35mm film format (actually 24x36 millimeters) is big enough to make excellent large prints and offers the widest range of film

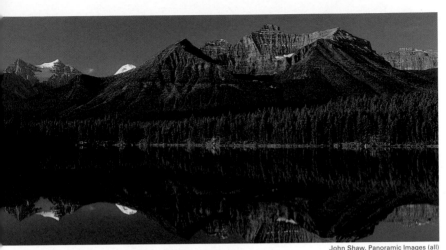

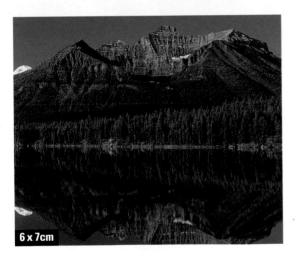

6 x 7cm

35 mm

types. SLR digital cameras are available, which use digital cards instead of film.

Single lens reflex refers to the fact that the photographer and the film see the subject through the same lens, so what you see in the viewfinder is what you get. This is particularly useful in careful compositions, where there is a risk of unwanted elements sneaking into the edges of the frame, and in close-up work. You

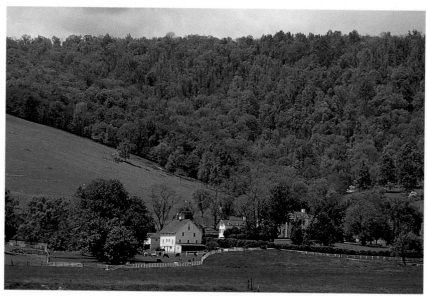

James P. Blair (both)

can also check depth of field and see the effects of polarizing filters. Be aware that most SLR viewfinders do not show 100 percent of the image area. Many crop a little off the edges; in some cases only about 95 percent is viewable. This is usually not a problem because slide mounts cover a little of the edges of the image area on transparencies, and negatives printed by automated machines are cropped even more.

35mm SLRs come in a range from basic, fully manual ones to those that are completely automated. Automated ones, with sophisticated multi-sample metering and highly accurate autofocus, can make properly exposed and accurately focused pictures in a variety of auto modes, but they also allow overrides of the automated features so that you can have more control of the image-making as your skill and experience grow. Or you can switch to fully manual mode for complete control of the process.

Tip

Many cameras have built-in diopter adjustment. If yours doesn't, you can usually buy an eyesight-compensation lens that attaches to the camera eyepiece.

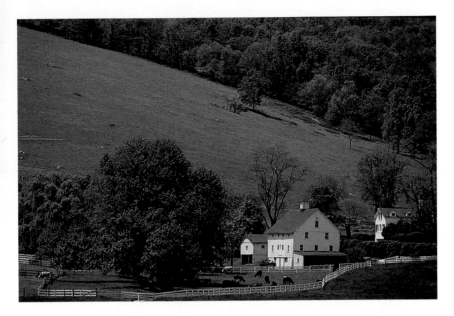

A normal lens reveals a farmhouse and its setting (opposite), but the image feels weak. Using a telephoto enabled the photographer to not only make the farmhouse appear larger, but also and more importantly, use the leading line of the white fence to guide the viewer into the frame.

There is a reason that 35mm SLRs are so popular. They are highly versatile and reasonably priced. If you are going to have one camera system and plan to make landscape photographs, the 35mm SLR is a good choice.

Medium-Format Cameras

Many landscape, architecture, and studio photographers use cameras that make larger images than 35mm film because the bigger the negative (or transparency) the better the quality. Since these photographers are usually shooting static subjects (or cooperative ones in the case of models), they do not have to be concerned about rapid movement and reaction

or worry about being unobtrusive. The most common image sizes in medium format are 6x4.5, 6x6, and 6x7. These are nominal sizes in centimeters, but actual frame size is slightly smaller. Larger image sizes are also available.

Medium-format cameras come in both rangefinder and SLR models, and the pros and cons discussed above regarding 35mm cameras apply. Automation varies from a little to a lot, including autofocus. The real advantage of medium format is the size of the negatives or transparencies. Being bigger, they record more detail and need less enlargement when printing, so grain remains tighter. If you plan to make very large prints, the difference will be noticeable.

The very thing that makes a medium-format camera better, though, is also its main drawback—size. The bigger film requires bigger and heavier bodies and lenses. This may not usually be an inconvenience, but if you are doing extensive hiking or climbing, it should be a consideration. The cameras and lenses are generally more expensive than 35mm gear, and long telephotos can be prohibitively so or even unavailable. Nonetheless, many professionals who shoot a lot of landscapes augment their 35mm systems with medium-format cameras.

> **Tip**
>
> A good camera bag is important for working in the field. You want one that is comfortable to carry and is the right size for all your gear.

View Cameras

Those huge cameras you've seen in old movies—when the photographer disappears beneath a black cloth to stare at an upside down and backwards image—are still around and still make the best landscape photographs. The large sheet film (4x5 inches is most common these days) records extremely fine detail and yields superb enlargements. Both front and rear standards can be adjusted to manipulate focus and

depth of field—you can tilt them up-down and left-right to correct for perspective distortion and to have both near and far subjects in focus.

View cameras are rather specialized equipment, so I won't go into great detail about them. Most are completely manual, are heavy and cumbersome, and are expensive to buy and to operate. They require patience, skill, and a lot of practice to master. But photographers who want extremely high definition and who plan to make very large prints find them invaluable.

Panoramic Cameras

Panoramic cameras are specialized to record a much wider view—from about 140 to 360 degrees of a scene—than that produced by conventional formats. They can be quite useful for certain landscapes and yield unusual and often very compelling images of places. Panoramic cameras work either with ultrawide lenses or by actually rotating the lens (or the whole camera) through an arc and recording the image on an elongated strip of film—24x224 millimeters in the case of one of the 360-degree cameras. They are made in both 35mm and larger formats, and some of the most popular ones produce 24x66-millimeter images in 35mm format and 6x12-centimeter or 6x17-centimeter images in medium format.

If you shoot with a panoramic camera, consider the compositional elements discussed previously and remember that you have a wide field to be concerned about. Panoramic cameras use optical viewfinders, so what you see may not be exactly what you get, and you cannot check depth of field, though this is not usually a problem with wide lenses since almost everything is in focus at all but the widest

aperture. Think about foreground and other elements that will not only carry your viewer's eyes into the picture, but also through it. And if you are using a 360-degree camera—duck!

Wide-Angle Lenses

Landscape photographs are most often made with wide-angle lenses for the simple reason that you can see more of the scene through them. They also have the advantage of great depth of field, so it is not difficult to have all the layers of a scene in sharp focus. There are several things that you should keep in mind, though, when using any lens with a focal length shorter than 50mm—and the shorter the focal length, the more pronounced the effects will be. (We use 50mm lenses as the "standard" in the 35mm format because they record subjects in about the same relative size as we see them.) The bottom line when selecting a lens for a particular scene is, as always, to look carefully and to think. Is what you see through the viewfinder what you really want? If not, use a different lens or find a location that works better.

Lack of a Point of Interest

As we discussed in the beginning of this guide, the most common failing of landscape photographs is the lack of a clear point of interest. Because wide-angle lenses take in such a wide area, and because every element within it is usually in focus, the images can be flat and boring unless you are careful to compose them in a dynamic way. Often, everything is present, but nothing stands out.

Foreground elements, leading lines, and other compositional techniques we discussed help overcome this tendency of wide-angle lenses to include too much. Think about what is most important in

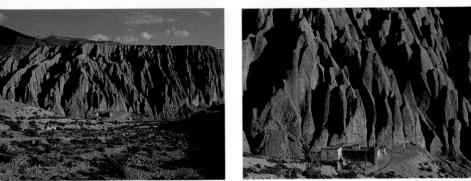

Robert Caputo

A remote temple in the Mustang region of Nepal is barely visible in the picture at left, so the image has no real point of interest. I switched from a wide-angle lens to a telephoto to make the temple appear larger. The long lens also drew the cliff toward the temple by compressing the scene, making the corrugated backdrop loom over the little building.

the frame, then use compositional techniques and the positive qualities of wide-angles to guide your viewers to it. You want to include enough of the setting to get a feel for the place, but not so much that you lose the point.

Perspective and Distortion

Distance to a subject controls perspective, not the focal length of a lens. But wide-angle lenses tend to exaggerate perspective because we use them closer than other lenses and because they allow us to get a close subject and a distant one in focus at the same time. A wide-angle lens exaggerates relationships by expanding the apparent distance between nearby and distant objects. Wide-angle lenses seem to enlarge near subjects and diminish those that are far away, and the shorter the lens, the greater this effect. These lenses also tend to elongate subjects that are near the edges of the frame. You can use these qualities to create very dynamic images, say of a huge moss-covered boulder in a valley

James P. Blair

Photographing this detail with a wide-angle lens and smaller aperture would have made the shot confusing—the grasses in the background would have been more in focus. Consider how you want your images to look, and use depth of field preview if your camera has it to make sure you are getting what you want.

with a mountain peak rising behind it. But avoid using a lens that is too short. You do not want to push the mountaintop so far back that it becomes insignificant.

If wide-angles are tilted up or down—even slightly—they will distort any vertical lines within the frame, making them appear as if they are converging. It's an effect known as "keystoning," which is particularly noticeable with buildings. When photographing natural subjects, keystoning is not usually much of a problem, since there are not many straight lines in nature.

The tendency of wide-angle lenses to distort is only a problem if it creates an effect that you do not want. Just as you must become familiar with any tool, you need to learn how different lenses work, and then employ them to get the photographs you want.

Depth of Field—Wide-Angle Lenses

Wide-angle lenses have great depth of field, and, again, the shorter the focal length, the greater the range. You should have no problem keeping all the elements of your image in sharp focus unless you are including something that is very close to the lens. If you are doing this, check the depth of field, with the preview button if your camera has one, to make sure you are getting what you want. If your camera lacks a preview button, use a smaller aperture and slower shutter speed—the smaller the aperture, the greater the depth of field. If this necessitates a shutter speed slower than 1/60, you will have to use a tripod or other camera-steadying device. Be conscious of wind. If a flower or tree is an important foreground element, any wind will blur it at slow shutter speeds. An advantage to shooting early in the morning, besides the great light, is that there is usually no wind.

Conversely, if you want one element to really stand out, you may not want all the elements within the frame to be in sharp focus. If too much is in sharp focus, open up the aperture and use a faster shutter speed.

Tip

In a hot environment, keep film in a cooler with ice. If you can't get ice, wrap a wet towel around the case holding the film. Evaporation will keep the case cool.

Telephoto Lenses

Telephoto lenses have the opposite effect of wide-angles: Telephotos have a narrower angle of view than a normal or a wide-angle lens, so they take in a smaller area of a scene. They make objects appear closer and larger, and they compress the apparent distances between them. The longer the focal length, the greater the effect. Telephotos range from 85mm up to 600mm or even longer, and the field of view gets narrower as focal length increases. In many cases, telephotos can enhance the compositional techniques we discussed

earlier: They can make your subject fill a foreground frame, accentuate leading lines and patterns, and make it easier to exclude unwanted elements. They are also useful if you simply cannot get physically closer to your subject.

Scanning

Wherever you are shooting, even if you plan to make only a wide-angle image, get out a telephoto and scan around. You will often find things you had not seen with your naked eye or with a wide-angle lens. If you have a telephoto zoom, look at the scene through varying focal lengths to see how they affect it. Look for details and for how the lens compresses elements within the frame. Use the properties of telephoto lenses to isolate interesting elements or to create graphic images of lines or contrast.

Perspective and Compression

Telephoto lenses exaggerate perspective because they narrow the field of vision and seemingly bring distant objects closer. Telephotos seem to compress, or "stack," objects within the frame, making them appear bigger and closer together than they really are. We've all seen images of a range of mountains or tree trunks made with telephotos in which the items seem to be jammed together. This is a useful and often dramatic technique. But there is another type of compression that you should think about.

In the example we've used in other chapters—the farmhouse on the prairie—let's suppose that there is a mountain in the background. If you shoot the scene with a wide-angle lens, the mountain will appear far away from the farmhouse and rather small. This will yield the feeling of isolation that you are after. But if you back off and use a long lens, the two will be compressed together so that the mountain

Tip

To see how compression works, shoot a row of tree trunks with a wide angle and a telephoto and compare the results.

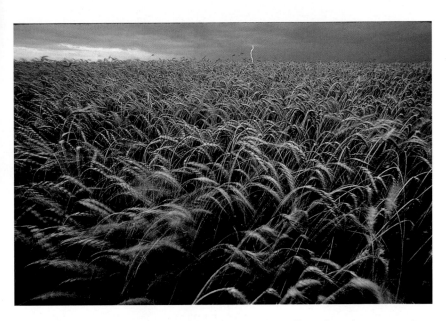

Depth of field and motion add interest to images. A medium-slow shutter speed allowed the wheat heads in the picture above to blur slightly, but was long enough to capture a distant bolt of lightning. By decreasing the shutter speed further, the photographer eliminated detail in the stalks and rendered the wheat field as texture.

Annie Griffiths Belt (both)

appears to loom over the farmhouse. This image will give you a very different feeling.

Depth of Field—Telephoto

Telephotos have very little depth of field, and the longer the lens, the less there is. Be very careful focusing, and be sure that the point of interest in the frame is sharp. Decide beforehand what you want in focus and what you don't, then check the depth of field to be sure the image will be what you want. You may or may not want the whole frame to be sharp. A good exercise is to shoot a row of tree trunks. If they are all pretty much the same, you might want them all to be in focus so that the image becomes one of vertical lines and patterns on the bark. To get all the tree trunks in focus, use a small aperture, slow shutter speed, and probably a tripod. If one of the trees, however, has a new leaf emerging (or some other interesting detail), you might want only it to be sharp and allow the others to be out of focus. In such a case, compose carefully—remember the rule of thirds—and use a large aperture and fast shutter speed.

Depth of field is another tool available for image-making. Always be aware of what it is by checking for it, and use it creatively.

Isolating Detail

Nature is full of gorgeous details, from the grand to the tiny, so always be on the lookout for them. Very often, an interesting detail can say as much—or more—about a place as a wide view can: Icicles hanging in a row from a branch might say "winter" better than a shot of the whole tree. Telephoto lenses are particularly good for isolating details, especially of things you cannot get near. Look at everything in the scene through one, and try to boil the whole experience down to one detail.

When shooting details with long lenses, be careful of exposure, focus, and movement. Think about the tonal quality of whatever it is that fills your frame. If it looks lighter or darker than neutral gray, you will have to compensate exposure. Telephotos have very little depth of field when close-focused, so be sure to get the right aperture/shutter speed combination for the effect you want. And even the tiniest movement is exaggerated with long lenses, so be sure neither the subject nor the camera is moving. You will probably need a tripod if you're shooting at a slow shutter speed—and with telephotos a slow shutter speed means anything slower than 1/250 or 1/500 because their weight and length make them hard to hold steady. If you do not have a remote release, use the timer so you can make the image without your finger jiggling the camera.

When you are out shooting landscapes, always be on the lookout for graphic or telling details, such as this leaf. Simple images such as this often communicate as much about a place as a wide shot.

Raymond Gehman

BRUCE DALE
Capturing a Sense of Place

AT THE AGE OF FIVE, Bruce Dale concocted a close-up camera out of an old roll-film Agfa, eyeglass lenses, and tissue paper. He wanted to make an image of a flower. Dale's passion for photography and his talent for creative technical innovations have been evident ever since. He had more than 50 photographs published in newspapers in his native Cleveland, Ohio, while still in high school, a precocity that led to a seven-year stint at the *Toledo Blade* newspaper. In 1964 he joined the staff of the National Geographic, where he had more than 2,000 images published during a 30-year career. Dale was one of the first photographers to become actively involved in digital photography, beginning in the 1970s, and he recently received an award from the Smithsonian Institution for his innovative work in the field. Since leaving the Geographic in 1994, Dale has expanded his photographic passion with a blend of journalism, advertising, and teaching.

One of the hallmarks of Dale's career with the Society was his evocative work with landscapes all over the world—from deserts to mountains, prairies to forests. He attributes his success to a

"Keep your eyes and mind open," says Bruce Dale (left). "You never know when a photograph will present itself to you."

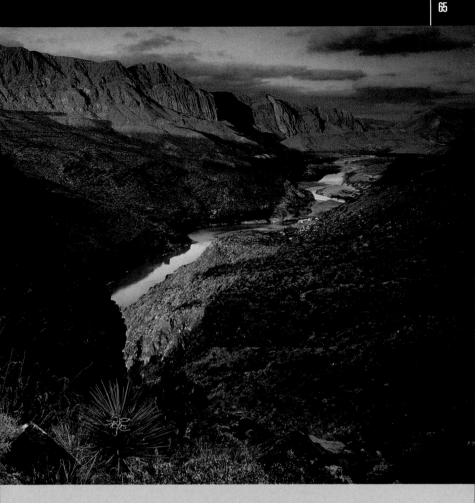

In Dale's image of the Rio Grande (above), a streak of sunlight parallels the river and carries us into the frame. The photograph was chosen by the U.S. Postal Service as the face of a 40-cent stamp.

combination of hard work, dedication, and luck. "When I have an assignment to photograph a new place," he says, "I do a lot of research. I look at postcards, books, Web sites—anything I can find about the place. If there is art or litera-ture—poems, stories, diaries of people who lived there—I study those, too, because I want to learn not just what a place looks like, but what it feels like, how it has struck other people.

"I set out with certain goals in mind, but what I really want is to discover something new, something that hasn't been shown before. Some of my favorite pictures are ones I made while on my way to the places everyone goes."

Every year, Dale teaches a workshop near Santa Fe, New Mexico. On his way back to the East Coast, he ignores the interstates and prefers to meander along back roads. "By just taking my time and keeping my eyes open, I discover something new every day. Then it's a matter of time, of being willing to wait or, if necessary, making the extra effort to come back.

"I've always had good luck following my instincts, but photography really is a state of mind. If you are not in the right frame of mind, pictures can pop up all around you but you can't see them. You have to be open to the place."

But the serendipitous discovery is not something you can depend on if you are doing a story for a magazine. "In every story, there will be subjects that you know you have to represent," Bruce explains. "If you have an assignment on the Rhine River, you are going to need a castle, wine, and the river itself. The editors and the readers will expect to see these things, and your job is to get good and, hopefully, new looks at them. Make sure that you spend an appropriate amount of time getting a photograph that illustrates these subjects well."

Dale usually works with 35mm equipment, and his images often look as if they were made with wide-angle lenses. Many are, of course, but more often they are not.

"A good landscape image, like any photograph, is largely about relationships and perspective," he says. "Most people think that when they are shooting a wide scene they should use a wide lens, but that is often not the case. It's natural to try to include everything, but you have to think about how objects relate to each other within the frame. Do you really want to include everything in the photo? Be selective, then try backing up and using a 50mm or 85mm lens to

A lone plant juts defiantly from the arid sand of a dune in this evocative image. The gentle sweep of the dune bisects the frame, and the energy of the plant is reinforced by its stalks thrusting skyward. Notice how Dale used the rule of thirds in placing both the plant and the moon.

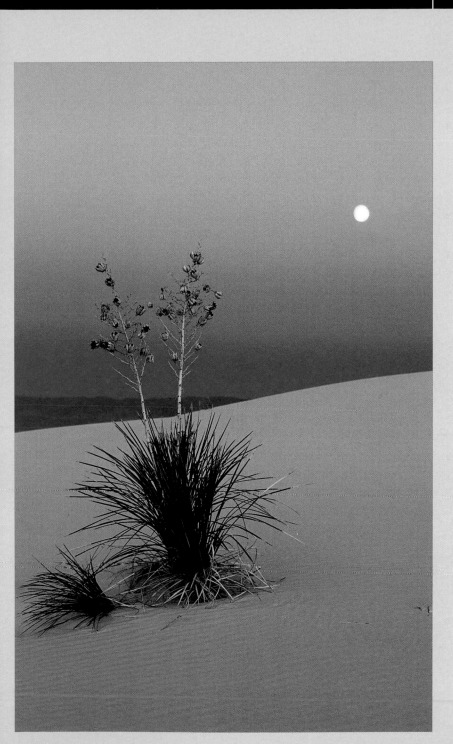

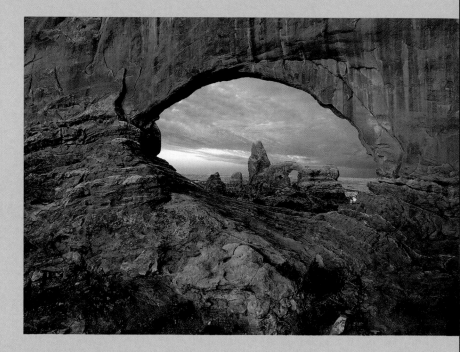

Avoid the bull's-eye—or don't. Sometimes, as in this perfectly framed composition, aiming for a bull's-eye works. The hole in the rock wall resembles an eye and imbues the image with an active sense of looking into the scene.

get a more pleasing perspective. I've made a lot of successful images this way.

"You have to learn to see as the film does. If you squint, or look at a scene through a heavy neutral density filter, you can cut down on the visual range your eye sees and more closely simulate the way the film will capture the scene. I also find it very helpful to close one eye. It eliminates the stereoscopic effect and puts you on the same two-dimensional plane as the photograph. Then notice how the scene changes when you move even an inch or two.

"I often use a graduated neutral density filter on the lens if a scene has a lot of contrast in it—a range of light beyond the capabilities of the film such as a bright sky with a shaded foreground. The purpose is not to change the scene, but to let you capture what your eye is seeing."

Dale is a wizard with equipment, and his

cameras include medium, large, and panoramic formats that he uses as the subject and the client demand. For his favored 35mm camera, he has a range of lenses from 15mm to 500mm as well as a host of filters and other accessories. But these are far from the most important things to him:

"Lenses, filters, and all the rest are tools. What's really important is to be open to the feeling of a place, to slow down and allow it in. Look at the scene from several angles, have the patience to wait for the right light, and if necessary return several times to find that magical moment that makes the scene extra special."

Dale's Photo Tips

■ Simplify your gear—less is more. It's often faster to move closer or step back than to fumble with gear that is encumbering you.

■ A good tripod is important for landscapes. If you are waiting for just the right light, you can be all set up and ready if the camera is mounted on a tripod. It's especially critical when you're working with graduated filters.

■ Pay attention to the times when the sun is just at the edge of the clouds. It softens the foreground in an almost imperceptible way.

■ Watch for the shadows the clouds cast on a scene. They can often contribute a lot to your images.

■ To check for the position of the sun and clouds, don't look directly at the sun. Hold your sunglasses in front of you so that you can see the sun in them and check the relationship between the sun and clouds in that reflection.

■ Be careful of the placement of the line if you are using a graduated filter. Hide it along a natural line in the scene. Tip it if necessary. Remember your lens will stop down when you shoot the image—the line will be a bit sharper than it looks through the viewfinder. Don't limit yourself to using the filter only on the sky—use it upside down if there is a lot of bright light, such as snow, in the foreground.

■ Sunlight is nice, but give me fog or rain any day. Moody light can make for some dramatic images, and greens take on a magical quality in rainy weather.

■ Wear good shoes. (I dislocated two shoulders and sprained three ankles before I learned this.)

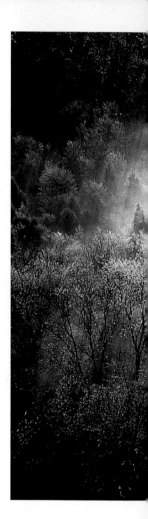

Capturing the Essence of a Place

Good landscape photographs are both of and about a place: They are documents of its appearance and its character. You get a certain feeling when you are outdoors gazing at some aspect of nature, and your images should convey that sense to the viewer. As we mentioned earlier, think of adjectives you would use to describe the place to a friend, and consider how best to visually convey their meanings. The time of day and of year you choose to make your photograph will have a great impact on how the place comes across. Would one kind of weather be better than another? Would early morning light be best? Would a different season be more appropriate? Getting the light and weather that best enhance the feeling you have about a place is the part of landscape photography that requires the most planning and patience. You may have to go back to it for several days, or even at a different time of year, to get what you really want. But a good image is worth the effort. There are, of course, times when you cannot go back—if you are traveling on an itinerary that does not allow for it. In this case, you have to do the best you can, using compositional and other techniques to make the best image possible in the circumstances. You can't do anything about the weather, but you can make the most of what you have.

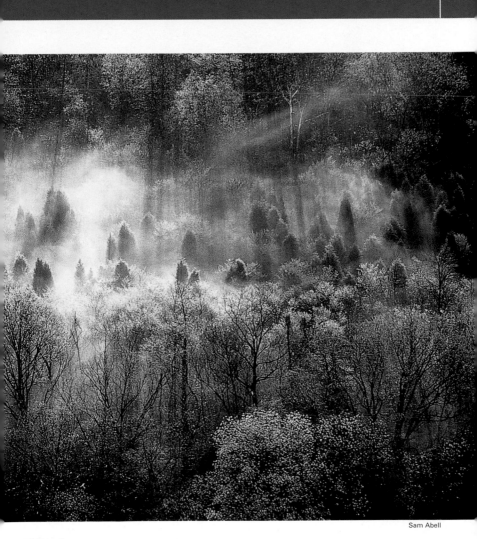

Sam Abell

Weather

Each kind of weather has its own particular quality of light and its own mood. Again, you should think about the landscape you are photographing and what kind of weather will best convey the feeling you are after: If you want a forest to feel brooding, for example, it would be more appropriate to shoot it on a foggy day than on a sunny one. We will discuss different kinds of weather in detail in the next chapter, but the important thing

The combination of back light, fog, and brilliant color lend this image of a forest in Virginia a beauty and serenity that really capture the sense of place. Don't be afraid to shoot against the light—it illuminates fog and creates dramatic shadows.

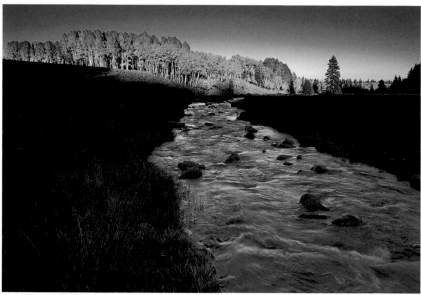

Bruce Dale

Photographs made at the same time and place looking in opposite directions: A graduated neutral density filter on a 20mm lens lessened contrast between shadowed foreground and lit background (above). An 80mm lens and foreground trees give focus and interest to what would otherwise have been a bland image.

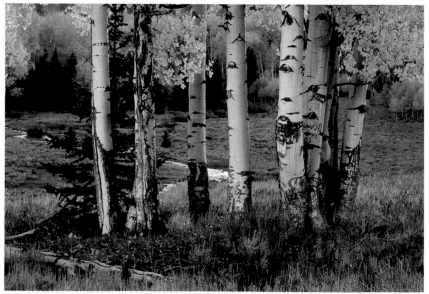

Bruce Dale

to remember is that so-called "bad" weather should not keep you from being out there and shooting—it can be exactly what you need.

Light and Mood

Quality of light is one of the most important elements of photography. The word, after all, derives from the Greek words for "light drawing." Light affects everything about an image, from the way a subject looks to the mood it conveys, and light is always changing. Each time of day has its own quality of light, as do various kinds of weather and different seasons. And qualities of light—of direction and color—befit different scenes and moods. When you are painting a house, you choose the color that enhances the mood you want for a particular room. You should just as actively choose the quality of light you want for your images.

Time of Day

The easiest way to see how light affects a scene is to look out your home or office window. As an exercise, look out in the early morning, around noon, and in late afternoon on sunny and cloudy days and in all seasons. The scene will look and feel very different each time, and you may want to make notes describing both the look and the feeling. Better yet, make photographs every time, then lay them out next to each other and compare the feelings they evoke.

Light is warmer early and late, when the sun's rays are longer and contain more of the red end of the spectrum. This, to our eyes, produces a more pleasant visual palette than the whiter and harsher light of noon. The longer shadows also create modeling, giving more contour and definition to a scene. Overcast days produce a bluer

Tip

If you are staying in one place for several days, check out the long-range weather forecast and plan your shoots around the weather that is best for specific subjects.

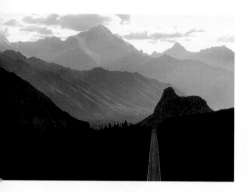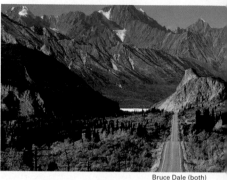

Bruce Dale (both)

Keep going back. These two images of the same scene shot at different times of day clearly demonstrate what a difference the quality of light can make. When you see a scene that attracts you, think about what light would be most appropriate and make an effort to be there at the right time.

light, making everything seem colder, and the lack of shadows makes objects flat. Similarly, notice how a room with warm incandescent lamps feels very different from one lit by overhead fluorescent bulbs. Light affects mood, and understanding how it does so will help your images convey the feelings you are after.

This is not to say that you should shoot all your landscapes in the warm light of sunny early mornings and late afternoons. When to shoot depends on what you want to say about a place, how it feels to you. Some images might call for harsh light, or you might want to use the heat waves that rise from a desert in the middle of the day. Other subjects might best be shot in the soft light of cloudy days.

Seasons

You can use seasonal qualities to reinforce the message of your landscape photographs. If you are making photographs from your window, as suggested previously, notice how the same scene looks at varying times of year. You will be amazed how the mood changes, just as a person's does.

Use the light and elements of the seasons to enhance your images. If you are making a

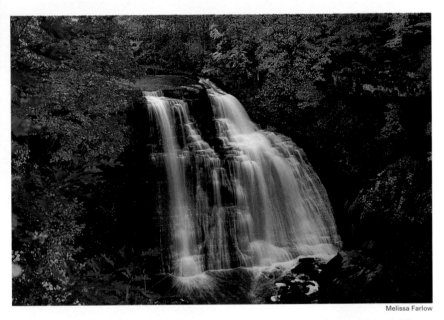

Melissa Farlow

Framed by fiery leaves, a waterfall seems to leap from the picture (above). The blur in the water indicates a slow shutter speed. Brown cliffs against snow create drama; imagine how different the two shots would look another time of year.

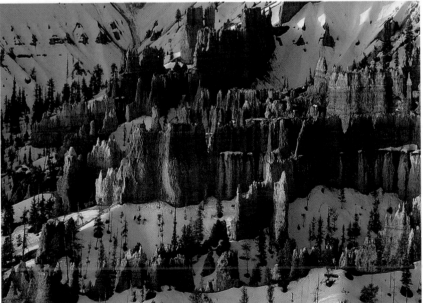

James P. Blair

photograph of a mountain, include a field of wildflowers in the foreground to accentuate the feeling of spring. In the winter you might include a frozen stream, in autumn trees with brilliantly colored leaves. Think about elements that express the feeling of the season in which you are shooting. But try to avoid clichés. Flowers obviously say "spring," and icicles scream "winter." Try to find a different way of viewing these subjects—a different angle, a different lens, a different background. You want your images to reflect how they strike you individually, to capture what made you want to photograph them.

Using Light

Frontlighting

We usually make photographs of landscapes with the sun shining on them from behind us—this is the way we normally look at things and the kind of light that makes scenes strike us. In most cases, the most flattering photographic light is when the sun is at about a 45-degree angle to the subject. This is not a hard and fast rule, however, and you should always move to see how different angles of light affect a scene.

At an angle of 45 degrees the sun gives modeling to the scene, casting shadows that make objects stand out in relief. If the sun is directly behind you, at 90 degrees to the subject, the landscape will look flat, devoid of contours that lend it depth. And, as we mentioned above, the lower the sun, the longer the shadows and the warmer the light. Frontlighting also generally brings out the colors in a landscape the best, and it allows the film to pick up more detail.

Sidelighting

But frontlighting is not the best or most appropriate for every subject. Sidelighting can create

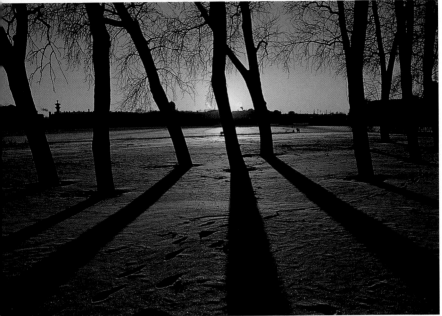

Sisse Brimberg

very dramatic effects, fully illuminating one side of your subject and casting the other half in deep shadow. If you are looking for shapes or patterns, sidelighting can often accentuate them.

Exposure can be quite tricky with sidelighting. In-camera meters that average a scene will tend to underexpose the lighted side and overexpose the shadow. Take the reading from the fully lit part by getting close to it or by using a spot meter if your camera has one.

Backlighting

Always remember to look over your shoulder in your search for good images. Backlighting can be used to create beautiful effects and to bring out qualities of subjects that may be hidden when they are lit from the front. Leaves, icicles, the feathery hairs around a head of wheat—all sorts of things look gorgeous when they are backlit and take on a completely different quality.

Backlight produces a spectacular graphic image in this shot of shadows and tree trunks. Hiding the setting sun behind a tree, the photographer kept the sky from blowing out by being over-exposed. The shadows serve as leading lines.

Backlighting is trickier to work with than frontlighting because it often creates great contrast within the frame. If you are shooting a scene in backlight, look at it carefully. What part of it do you want to be properly exposed; in which do you want to see detail? If there is a lot of sky, the brightness in it may overpower the scene and fool the meter into underexposing everything else. If the sky is an important element, that's fine; if it's not, try to compose differently to eliminate most of it. If you keep a lot of sky in the frame and expose for something on the ground that is backlit, the sky will "blow out" and be distracting.

When a subject is backlit, you usually want to see the detail in it and have the fringes a bit bright. You should meter off the subject and think about how everything else will be rendered. But there are also times when you want the subject to be in silhouette. In this case, expose the background properly and photograph the subject against it. Whenever you shoot into a sunrise or sunset, you are shooting a backlit scene.

Adding Light: Fill-in Flashes and Reflectors

Often, subjects in the foreground of your image will be in shadow or in different light from that shining on the background. This is especially true if you are shooting in a backlit situation, but it can also occur if a tree, canyon wall, or something else is casting a shadow. If the image you're after is one where the shape of the object—the outline of a tree, for example—is most important, then casting it in silhouette is an ideal approach. The graphic outline is more interesting than the tree clearly rendered. If you want detail in the tree, however, you will have to add light. Adding light also helps overcome some of the harshness of

> **Tip**
>
> To learn how light direction affects the look and feel of images, photograph a tree lit from the front, the side, and the back.

midday sunlight by softening the shadows on your subjects. If you are making an image at a less than optimal time of day, you can use a reflector or flash to get a decent image out of what might otherwise seem unphotogenic.

In general, subjects in the foreground and reasonably close are the ones you should think about—consider how much or how little detail you want in them. Objects that are far away and rather small may not matter too much since the viewer will not be able to see them clearly. If there's something that you consider important, you can add light to it no matter what the distance. If you are using a reflector, set it up near the object so that the light is strong enough to register. If you are using a flash, set it up with a slave, a remote trigger that activates the unit when the camera is fired. Be sure that the slave can "see" the transmitter when using optical and infrared systems. This is unnecessary with radio slave systems. (Most optical slaves work only around dusk, dawn, and at night, when there is little ambient light.) Use multiple reflectors or slave-activated flashes to light up several objects.

Reflectors

Almost anything white will reflect light onto a subject—a piece of white cardboard or construction paper, a sheet, etc. There are also several commercial reflectors, some of which pack into quite small packages so that they are easy to carry. Some of these are white on one side and gold, which throws a stronger light, on the other. Be aware that the light from the gold side is quite contrasty and warmer than the sunlight.

The apparent size of the light source from the position of the subject determines the hardness or softness of the light: The closer the reflector is to the subject, the softer the light that it will reflect.

FOLLOWING PAGES: There are many and various ways to add light to a landscape. Except for fading light in the sky, this scene is lit only by the glow of a campfire, captured with a slow shutter speed of 1/4 of a second.

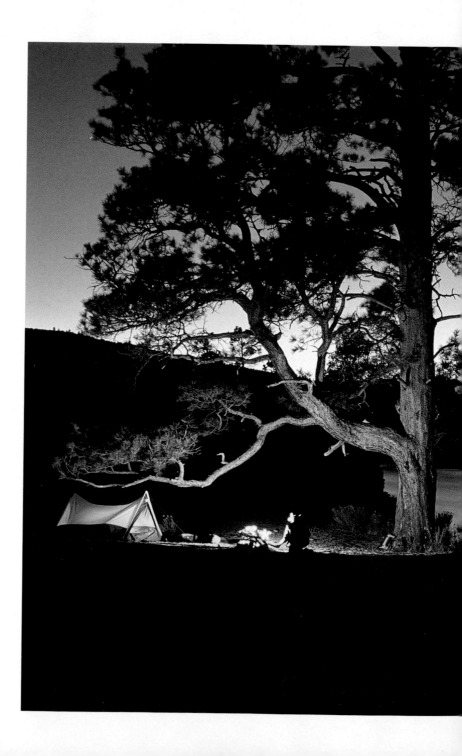

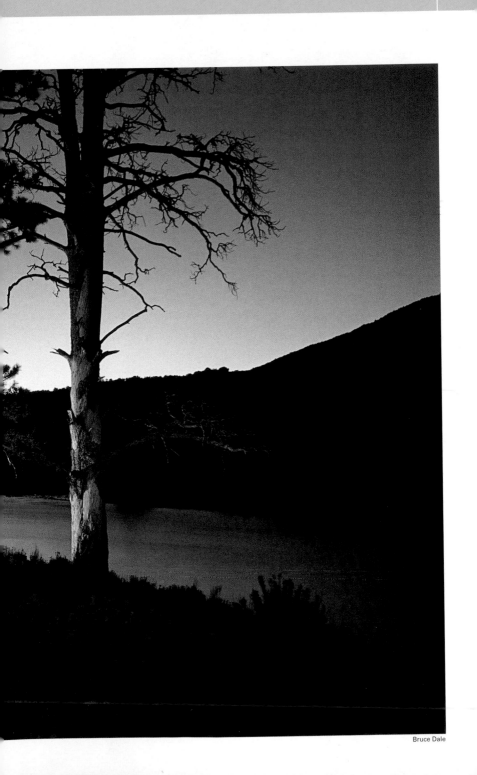

Bruce Dale

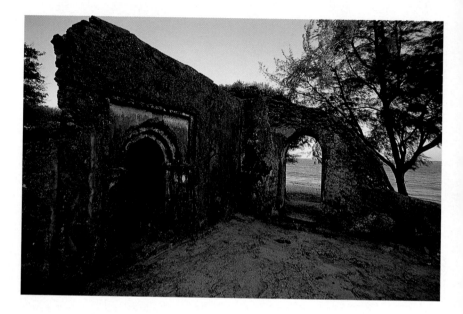

You will be able to see the effects of a reflector just by looking at the subject as you move the reflector to bounce less or more light. The closer the reflector is to the subject, the stronger the light, and whatever is most pleasing to your eye will also probably be the most pleasing to the film. Think about what qualities you want to emphasize in the subject: Do you want to see full detail? Then you should try to make the light on the subject equal or nearly equal to that on the background. If you want the subject to be slightly darker, then bounce a little less light into it, and so on all the way down to full silhouette.

Flash

You can use flash units to add light to subjects within your frame, and the same principles apply as with reflectors. Think about how much or how little light you want to add to the subject, and then adjust the flash unit accordingly. Most modern flash units incorporate features that allow you to adjust the output, often in 1/3-step

Tip

Be sure to hide a remote flash or reflector behind a rock or other object so that it does not appear in the frame.

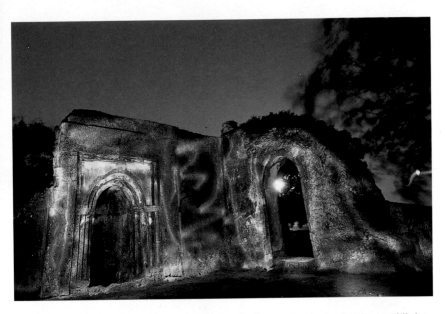

The ruins of a mosque by the sea posed a challenge due to the setting and light. I waited until dusk, then put the camera on a tripod, set the shutter to bulb, and painted the mosque with a flashlight. Make several exposures in such a situation; the results are somewhat unpredictable, as the upper image demonstrates.

Robert Caputo (all)

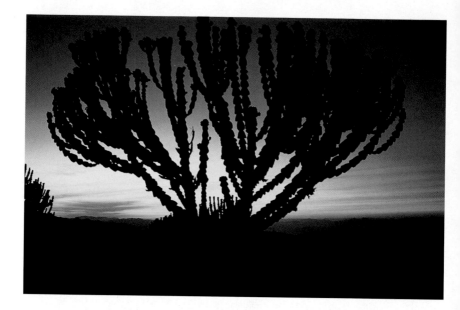

increments. If you make no adjustments, the flash will throw out enough light to make the subject of equal exposure value to the rest of the scene. If you want full detail, this may be right. If you want the subject to be slightly darker, decrease the output by a third, two-thirds, a full stop, or even more, depending on the effect you want.

If your flash unit is mounted on the camera, the light will hit the subject straight on. You may want to hold the flash to one side to get a slightly less direct hit. Most flashes have cords so that they can be removed from the camera and still communicate with it. Remember that flashes have only a certain range. You can't use one on your camera to light up something that is far away. Move closer, or use a slave as mentioned previously.

Exposure and Bracketing

There is nothing worse than looking at processed film and seeing an image that would

Tip

Gaffer's tape is an essential photographic accessory. Among its innumerable uses: taping reflectors and flashes in place, labeling film type on the back of cameras, and sealing camera cases.

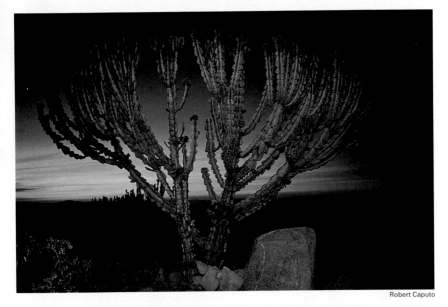

Robert Caputo

Adding light with electronic flash: A full silhouette of this euphorbia was a little too dramatic, so I decided to add light from an on-camera electronic flash. You can bracket the amount of light your flash unit throws out to get the balance you want, in this case just enough to bring out some of the detail and color of the plant.

have been perfect if the exposure had been correct. So always choose your exposure carefully. Modern cameras have remarkably sophisticated metering capabilities, but even these can sometimes be fooled. When you look through the viewfinder, think about the tonal qualities of the subject. If you are shooting a beach, a snowy hill, or a scene with a lot of white sky, the in-camera meter will tend to underexpose. If what you see is very dark, the camera will overexpose. Take your reading from a gray card like the one on the inside cover of this book, or from something in the scene of equal tonal value. Many photographers rarely use in-camera meters, preferring

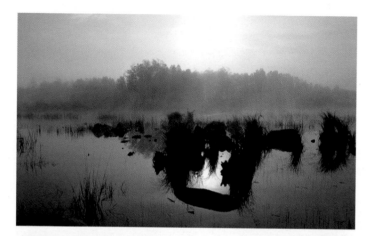

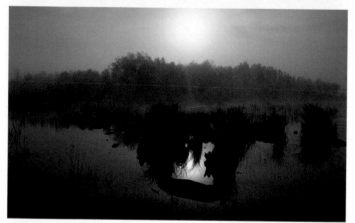

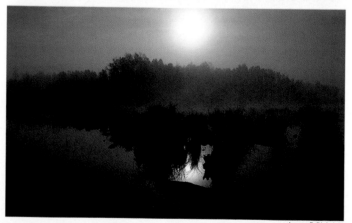

James P. Blair (all)

separate incident-light exposure meters. The word "incident" in this usage refers to the light striking or falling on the scene. The reading from an incident meter is very accurate. It is about a half stop different from that taken from a gray card because meters are now calibrated to 12.5 percent. This, which modern scientific studies show is the amount of light an average scene reflects, is a half stop less reflectance than a gray card. For the sake of consistency, gray cards have continued to be 18 percent gray, but instructions usually make this differential clear.

Proper exposure is critical to good photographs in part because film and digital cards are not nearly as agile as our eyes. When we look at a scene, our eyes adjust so quickly that we can see details in both highlighted and shadowed areas with no apparent effort. Film can't do this. Determine where you want to see detail and then expose accordingly, always keeping in mind what will happen to the other parts of the frame.

In any situation, and especially in landscape photography where you have plenty of time, it makes sense to "bracket" your exposures—that is shoot the scene three times and vary the exposures above and below the starting point. Negative film has quite a bit of latitude, so you can be off on your exposure by a stop or even more and still get a good print. Transparency film, however, has very little latitude, so you need to be accurate. Bracketing ensures that you will get at least one image with the proper exposure.

The other reason to bracket is that shutters are

Tip

To learn more about your favorite film, bracket a scene a half stop in each direction and then examine the results to see how the film handles differences in exposure. Many professional photographers, for example, expose Kodachrome 64 at 80.

Bracketing exposure changes the look and feel of a scene, especially one like this, which contains a combination of bright and dark areas. Always bracket tricky lighting situations to ensure getting the effect you want.

mechanical things and are not always 100 percent accurate. You may set the shutter speed at 1/125, but chances are that the actual time of exposure is not 1/125—it may be 1/100 or 1/150. To compensate for this variation, you need to bracket.

The most common way to bracket is to make three images—at your reading, a half stop

This scene, with its predominance of dark areas and brilliant setting sun, cries out to be bracketed, especially if you want to get the highlights on the clouds. Given the effort and expense of getting somewhere, don't worry about the cost of a few frames of film.

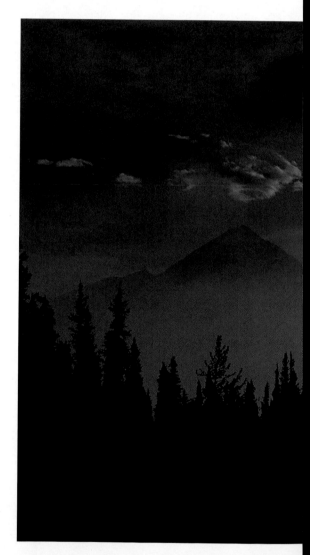

under, and a half stop over. Some cameras can even be programmed to do this automatically. This technique uses up a bit more film than making just one exposure, of course, but if it guarantees a good frame, it is well worth it. Just compare the cost of a little more film to the costs of a trip, and you will find it isn't much.

George F. Mobley

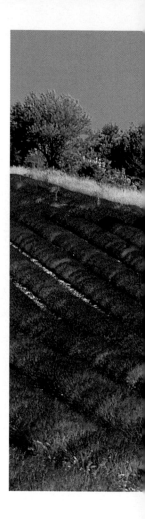

Sunny Days

We most often shoot landscape pictures on sunny days—they are the kind that lure us outdoors in the first place, and they usually both look and feel good. But there are a few thoughts you should keep in mind, some of which we have touched on before.

As we discussed in the last chapter, the warmer quality of early morning and late afternoon light is generally most pleasing and often makes landscapes look their best. Get out early and stay late to take advantage of the low angle of the sun. When you scout a location, consider how the sun would fall in the morning and afternoon and plan your shoot for the best light.

But shooting early or late is not a hard and fast rule. You might want to photograph certain landscapes in midday light, if the effect you want—say severity or harshness—is best achieved by doing so. In this case, don't be afraid to shoot around noon. You might want to use a reflector or fill-in flash to add detail to a subject in the foreground. You also might want to include lens flare if it helps the overall effect. Be careful when you use lens flare, though. If done right it accentuates the feeling of "hot," but if it is slightly off, it will produce a fog on the image. You can check lens flare by using the depth of field preview button if your camera has one. Use a lens hood to reduce unwanted lens flare.

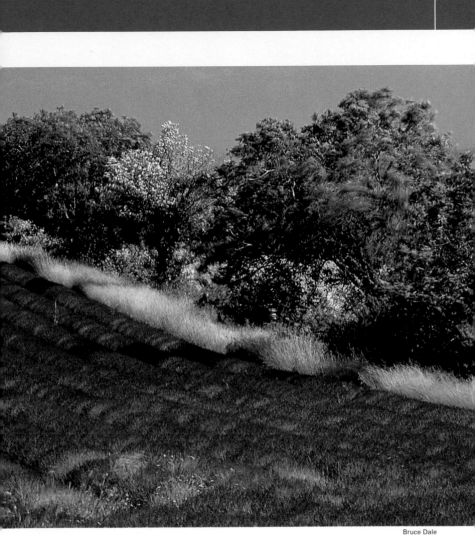

Bruce Dale

Cloudy Days

Just because the sun isn't shining, don't assume making great landscape pictures is out of the question. Remember, too, that there are all kinds of clouds, from completely socked-in dull to puffy white. Cloudy skies can enhance the mood of landscapes, and they can make possible evocations that are impossible when it's sunny.

If the clouds in the sky are not too thick and show an interesting pattern, you can make them

The intensity of a summer's day radiates from this image made in bright sun, the light bouncing off the purple and green plants. Determine what light and weather conditions would best help you convey the character of a particular scene.

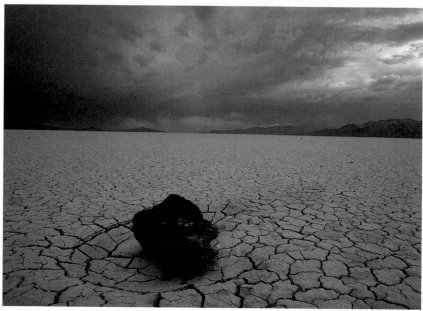

James P. Blair

Cloudy days can be very effective, especially to evoke a mood. In this shot, the photographer has given the sky and the pan almost equal weight.

part of the composition of the image. If they are just a thin white sheet, though, you will probably want to compose in a way that minimizes their presence in the frame—they will appear in the photograph simply as a white mass. Be careful metering if there's a lot of white sky—in-camera meters will tend to underexpose.

Thick clouds can help make landscape pictures beautiful because the light penetrating may be very soft and muted, increasing the color saturation of the film. Especially for images in which rich color is important, such as autumn leaves, thick clouds can be a bonus. If you are shooting with slow film, which is usually preferable because of its fine grain and color rendition, be conscious of depth of field. There may not be a lot of light on very cloudy days, and you may have to use quite a slow shutter speed (and a tripod) to get the depth of field you want for the image.

Tip

Shoot a rainy scene with both fast and slow shutter speeds to see the effects of freezing and blurring.

Rain

Rain can produce some beautiful images, so don't be put off by the prospect of getting a little wet—just try to keep your gear dry. Especially for moody shots, rain can add atmosphere. First, think about how you want the rain to appear. Raindrops usually will not show up very well against a light background, so try to offset them with something dark behind them. If this isn't possible, try to find something that makes it apparent to the viewer that it is raining—raindrops creating circles on a lake, for example. Also look around to see how the rainfall is affecting your scene. Water may be glistening on leaves or rock surfaces, colors of moss and other

Three shots of the Pecos River in various seasons convey very different feelings about it: the misty cold of winter (below), and the extremes of the rainy and dry seasons, as shown in two close-ups taken at the same spot. If you have a favorite place near your home, photograph it at different times of year to see how the weather affects the mood of your images.

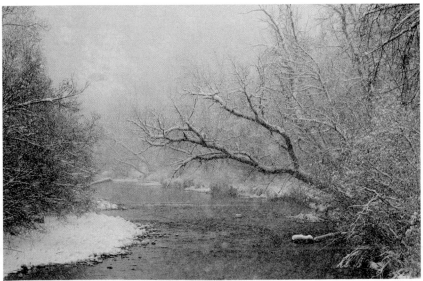

Bruce Dale (all)

plants may be richer, and the windward side of tree trunks may be darker, adding contour. You want the viewer to know that it's raining, so look for things that make it obvious.

Determine whether you want the rain to be frozen in place or streaking through the image. If you want to freeze it, use a shutter speed of at least 1/125. At 1/60 the rain will record as streaks that get longer as the shutter speed gets slower. Remember to shoot the drops against something dark.

To keep your equipment dry, stand on a porch or under some sort of overhang. There are commercially made plastic covers for cameras, but you can also use a plastic bag: Wrap it around the camera, leaving one hole for the lens

The river of fog running through the valley below creates a leading line that carries our eyes into the frame and gives this scenic a feeling quite different from one made on a clear sunny day. Similarly, fog-shrouded trees shot against the sun result in a moody image unlike one of the same stand on a bright day.

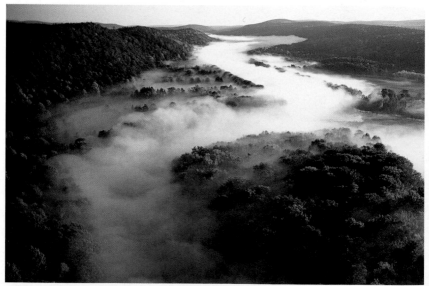

Sam Abell

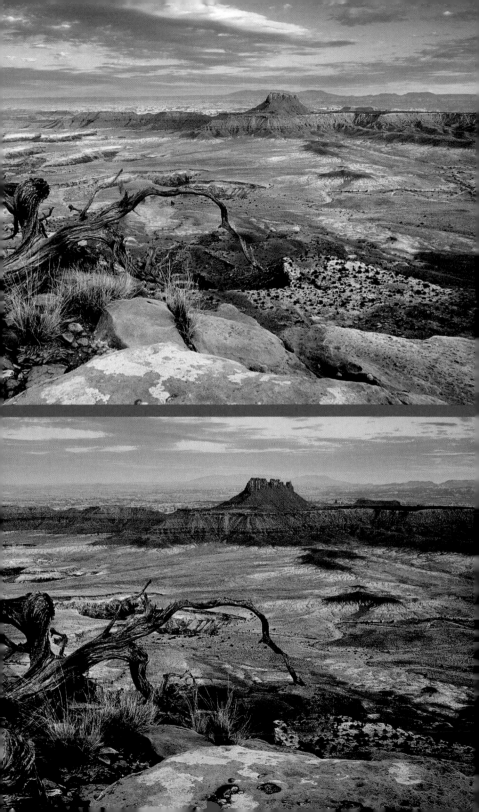

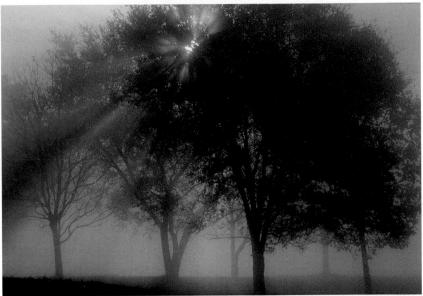

Annie Griffiths Belt

and another for your eye. Lens hoods are a good idea too, but it's almost impossible to keep some rain from getting on the lens. Check and clean it frequently if necessary.

Fog and Mist

Another reason for getting up early when you're making landscape photographs is to be on site in case there's fog or mist—it doesn't take very long for the sun to burn these off. Fog enveloping a highland forest or mist rising slowly from a lily pond can add dimension and feeling to an image and can create an air of mystery. Local people can often advise you where and when there is likely to be mist.

Like clouds, fog and mist come in all sorts of densities: They can be white or gray, thick or thin. Be very careful metering. Think about the tonal quality of the fog. If it appears lighter than neutral gray, take a reading from your subject or

Tip

If you are using flash, consider the thickness of the fog or mist. If it is moderately thick, light from the flash will bounce off the water droplets without reaching the subject, much as car headlights light up fog and not the road. If detail in a subject fairly near is important, use a remote flash setup with a slave near the subject to penetrate fog and mist.

from a gray card. Always remember that your eyes can see detail a lot better than the film, so if detail is important and the fog or mist is thick, you may want to move closer to your subject.

Shooting in fog and mist is one situation in which it really pays to have good lenses—the better the lens, the better the light transmission to the film, and the more detail in the image. It also pays to bracket, because it takes a lot of practice to get a balanced exposure that works for both the fog and the subject.

Snow

The most frequent problem people have when making photographs in snow is underexposure. All that white easily fools meters—they try to make it mid-tone gray. Take a reading from your subject or, if that's not possible, use a gray card or something else of equal tonal value, making sure that it is in the same light as your subject. Don't be surprised if that reading is as much as two stops different from that of your in-camera meter.

If you are shooting a lot in the same snowy situation, you can set the exposure compensation control included on many cameras so that you don't have to go through the calculation process for every shot. Determine what the difference is between what the camera is reading and what you've found is the proper exposure. If it is a difference of one stop, set the exposure compensation control to +1, et cetera.

If your camera does not have an exposure compensation control, you can accomplish the same effect by changing the ISO rating of the film or digital card. If you're using ISO 100, change it to ISO 50 so that the camera meter will give the film twice as much light. (Halving the ISO doubles the amount of light hitting the film

Tip

If you're shooting falling snow, think about how you want it to appear. You can freeze or blur it just as you can rain, though 1/60 will often freeze gently falling snow. Don't use too slow a shutter speed or snow may look like fog.

Paul Chesley

or digital card; doubling the ISO halves the light. Each f-stop lets through twice the light of the preceding, smaller f-stop.)

As with most situations, shooting early or late is best on sunny days in the snow. The long angle of the sun gives contours to mounds, ridges, and other irregularities in the snow and casts a warmer light. Try not to shoot with the sun directly behind you—the light bouncing straight back at you from all that white will be blinding and devoid of detail.

Protect your gear from both snow and cold. If it is snowing, wrap the camera in a plastic bag as you would for rain. If it is severely cold, try to keep the camera reasonably warm so that the batteries will work efficiently and the film does not become too brittle. Film leaders can snap off, making those rolls useless. It is a good idea to keep your camera inside your outer

Scenes of snow create real metering problems, as in-camera meters want to underexpose all the white. Be careful metering, and use a gray card if you can. Notice how the photographer has placed the lone tree off-center for a more pleasing composition.

Todd Gipstein

Isolating windblown palm trees against the sky creates a spectacular storm image. The force of the wind is implied in the motion of the branches, captured with a slow shutter speed.

jacket, pulling it out to make photographs and returning it when moving. You don't want the camera to get too warm, though, because water will condense on it and then freeze when you pull it out.

Remember, too, that flesh sticks to very cold metal. Cover parts of the camera you will be touching with tape, including the place where your nose presses against the body. To keep condensation from forming on the equipment when you enter a warm room, put it in a sealed plastic bag while you are still out in the cold and allow it to warm up before you remove it.

You want your images to say "cold," so look for details that communicate that feeling. Ice coating branches or berries, wind whipping snow over a

mountain pass—any detail you can include in the frame will help convey your message.

Storms

Photographers love storms. The wild skies, high winds, horizontal rain, and other effects make for really dramatic images. You can often get a good shot of an otherwise not too interesting landscape if there is a great stormy sky over it— the sky becomes the subject. Feel the power of a storm when you are in it, and find ways to convey that intensity with your camera.

Look around for subjects that really show the power of the storm, and then find ways to compose that accentuate the effects the weather is having on them. The main thing to think about is exposure, for various exposures can make the same storm scene look quite different—do you want to freeze the tree branches bent by the wind or let them blur?

Consider what you want the image to look like, and then determine what exposure will achieve the effect: If you want horizontal rain slashing through the frame, use a slow enough shutter speed to let it streak a bit. A tornado calls for a fast speed to catch the action.

The sky is usually an important element of storm pictures, but be careful metering. A very dark sky can fool the camera meter into overexposing the whole scene. If you are photographing shafts of sunlight piercing the clouds, don't take your reading from them or the meter will underexpose. Always look for something of neutral tonal value to meter, or use a gray card.

Lightning

If there is lightning in the scene, you'll have to be patient as well as lucky: You never know where

> **Tip**
>
> If the film snaps due to the cold, you can use your jacket as an emergency darkroom and remove it and stow it safely. Commercial changing bags are also available.

FOLLOWING PAGES: Freeze or blur? In this case, the photographer used a shutter speed slow enough to depict the violent motion of the trees and water but fast enough to keep them from blurring completely. Including the shoreline gives us more information as well as feeling.

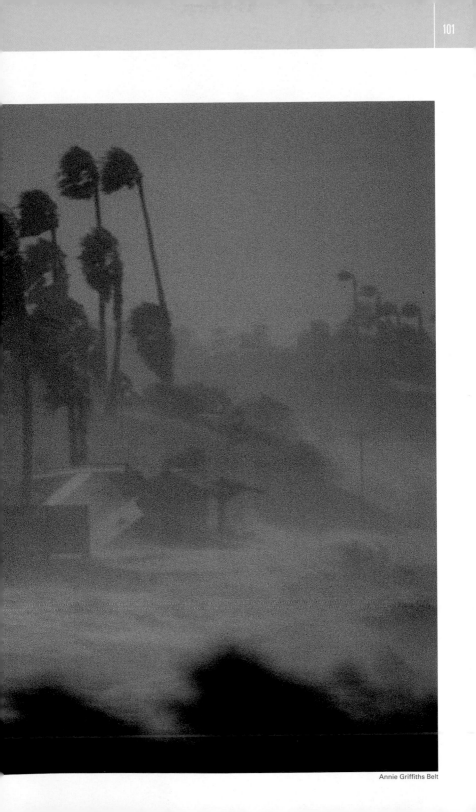

Annie Griffiths Belt

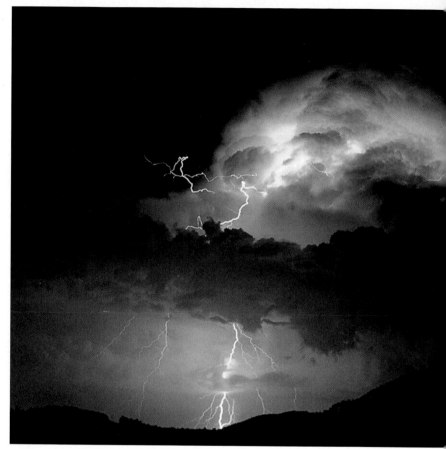

Michael Nichols

To photograph lightning, leave the shutter open long enough for the streaks to paint the film. You never know exactly what you will get, so make several exposures at various shutter speeds.

lightning is going to strike. Make sure it doesn't strike you: Don't stand under trees, steer clear of metal fences and pipes, and be sure to stay low to the ground.

If you are photographing lightning at night, put the camera on a tripod, set the shutter speed to bulb, choose a lens that encompasses a large enough area to give yourself a reasonable chance, and use an f-stop of 5.6 for slow film (ISO 50) or 8 or 11 for ISO 100 or 200 film. (See the chart on page 103 for various settings in low-light situations.)

Aim the camera at the part of the sky in
which the lightning is blazing, focus on infinity,
and keep the shutter open for several flashes. If it
is early enough in the evening that some light
remains in the sky, or if you are near a city, you
will need to limit the exposure to between 5 and
20 seconds because of the ambient light.

If you are photographing a landscape with
lightning during the daytime, you have to be
even more fortunate than you do making the
picture at night.When shooting during the day,
you can't leave the shutter open as long as you
can at night.

To give yourself the best chance of capturing
the daytime flashes, figure out what the exposure
time is for your smallest aperture (usually f/22),
mount the camera on a tripod, and hope you
get lucky.

For both daytime and nighttime pictures,
make several exposures.

Recommended Exposures for Low Light and Lightning

Making photographs in very low light and of lightning is tricky. Below are some recommended settings, but these should be taken only as a starting point. The best way to learn is to make several different exposures and to keep notes about them. When you get the film back, you can study the images and the settings to determine what works under what conditions. For lightning with little or no ambient light, leave the shutter open until you have seen one or more flashes. If using a digital camera, consult the instruction manual for advice on shooting in low-light situations.

Lighting Situations	ISO 50-100	ISO 125-200	ISO 250-400
Full moonlit landscapes	4 minutes f/4	2 minutes f/4	1 minute f/4
Full moon scene of sand or snow	2 minutes f/4	1 minute f/4	30 seconds f/4
Lightning with little/no ambient light	open shutter f/5.6	open shutter f/8	open shutter f/11
Lightning with ambient light	5-20 seconds f/5.6	5-10 seconds f/5.6	5 seconds f/5.6

Sunset and Sunrise

When shooting sunrises and sunsets, be very careful metering. The ball of the sun will be very bright on clear days, and you will have only a few seconds to shoot before it becomes too bright for the film. Cloudy or hazy days are actually the best for shooting. Clouds and haze diffuse the light, add more colors to the sky, and make the solar disk softer and more photographable for a longer time. But even when the sun is softened by clouds or haze, don't meter directly at it—look for mid-tones. In most cases, metering in the area of the sky about 45 degrees away from the sun should be about right. It's always best to bracket sunrise and sunset shots to ensure getting the right exposure.

If you are using a wide-angle lens, the rising or setting sun will be a rather small element of the image. This effect may be just what you want if the rest of the scene is beautifully lit and the sky is full of colors. If you want the sun to be big, use a telephoto, and look for something to silhouette against it or a part of the sky near it. The longer the lens, the bigger the sun will appear in the frame.

If you want detail rather than a silhouette of a subject in the foreground, you will have to use a reflector or fill-in flash to illuminate it. If using a flash, set it to underexpose a little bit (say one- or two-thirds of a stop) to soften the contrast

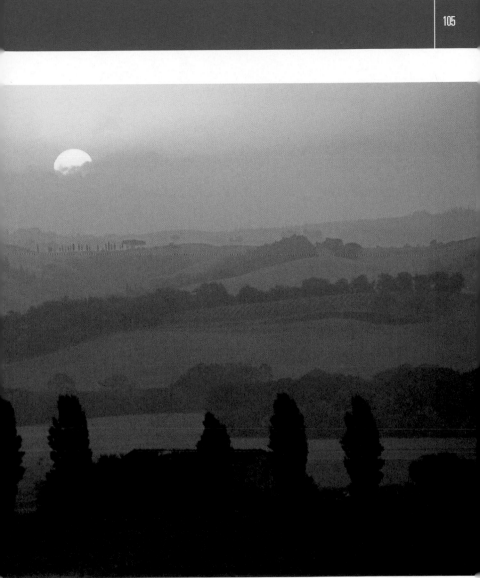

Robert Caputo

somewhat. You usually don't want to overpower the feeling of the early or late light.

As with any photograph, think about composition and how your image can say something about the location. A telephoto shot of a rising or setting sun alone is not all that interesting—it could be taken anywhere. Look for elements in the scene or in the sky that will communicate the sense of place.

Get out early and stay late. The soft light before dawn and after sunset makes for great landscapes. I got to the site above before dawn, then waited for the sun to peek from behind the clouds.

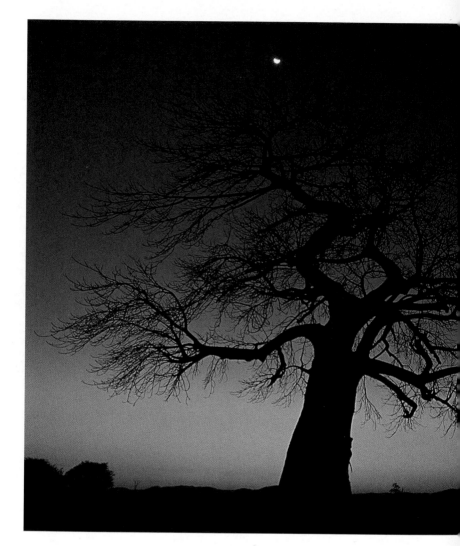

Just before Sunrise/Just after Sunset

You will usually have a little time to shoot land-scapes in the soft, diffuse light before sunrise and after sunset—how much depends upon the weather, the season, and the part of the world. It's a good idea to scout locations for this kind of shot beforehand to find appropriate scenes:

The photographer captured the silhouette of this baobab tree just at the right moment—there was still color just above the horizon, but the sky was dark enough for the moon to stand out. When you find a location you like, get set up and wait for the light to change. But be ready—it changes quickly.

Chris Johns

Dark green forests usually don't register very well, whereas sand or snow scenes will. They require quite long exposures, so use a tripod. And be careful metering. Look for the neutral tone or use a gray card. You are usually looking for that moment when the light in the sky and that on the ground are balanced, and it doesn't last long.

Find something—a stand of trees on a ridge, an interesting rock formation, for example—to silhouette against the royal blue of a cloudless sky before sunrise on a clear day or the oranges and pinks in a cloudy one after sunset. Again, think about metering. The area in which the sun is about to rise (or has just set) will be brighter than the rest of the sky, so meter about 45 degrees away from it. Think about your silhouettes, too. Wait to shoot them until your subject stands out in contrast to the sky. Sometimes, especially if water is present, you may have a combination of bright and dark spots in the scene. Meter on something of neutral tonal value and cast your silhouette against one of the brighter areas. And bracket. These are tricky shots, especially with transparency film.

Night Photography

You can't shoot landscapes (or anything else) without at least some light, so night shots are best made when there is a full or almost full moon. These shots work best when the scene has at least some fairly bright, reflective areas, especially when these throw light up behind darker ones. Night shots require very long exposures: about 4 minutes for ISO 50-100, 2 minutes for ISO 125-200, and about 30 seconds for ISO 250-400. If the scene is of snow or white sand, cut the exposures in half. Again, bracket. Numerous different—but equivalent—combinations of shutter speed and f-stop will produce the same exposure. According to this concept of "reciprocity" or "equivalent exposure," a long exposure in low light will give the same results as a short exposure in bright light. The concept fails for long exposures—one second or more—due to the composition of film emulsions.

Tip

If you want circular star trails, point the camera at the North Star.

Shooting the Moon

If you are including the moon in your shot, do
not expose for longer than one quarter of a sec-
ond. The moon will streak into an oblong white
mass, and the distortion becomes more notice-
able the longer the lens. The best time to make
landscapes that include the moon is when it rises
near sunset—there will
be plenty of ambient
light on the land, and
the moon will be low
and appear big. Try to
compose using some-
thing other than a
wide-angle lens if you
want the moon to be
more than a white dot.

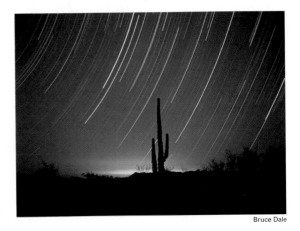

Bruce Dale

If you are shooting
the moon itself, use a
long lens or a telescope,
many of which have
camera mounts. You can also silhouette subjects
against the moon. Be sure that you are exposing
properly; the in-camera meter will tend to
underexpose the bright moon. Open up, and
bracket. Usually, the old "sunny 16 rule" works
for proper exposure—f/16 and the shutter speed
closest to the ISO speed of the film.

Stars

Shooting star trails across the sky requires expo-
sures of 15 minutes to several hours depending
upon how much of the arcs you want. Use a fast
film, open the diaphragm all the way, and focus
on infinity. Star trails are best photographed on
clear moonless nights away from light pollution
of cities. Try silhouetting a tree or other subject
against a starlit sky. This requires experimenta-
tion, but the results can be beautiful.

Shooting star trails
requires long expo-
sures of 15 minutes or
more, depending on
how long you want the
trails to be. By silhouet-
ting a cactus against
the night sky, the
photographer of this
image gives us an
evocative feeling of the
desert at night.

Always be on the look-out for telling details—they can say as much about a place as a wide shot. This close-up of a tree trunk evokes the feeling of the textures, and by composing with the large knot at the top, the photographer suggests that the tree is looking back at us.

The Telling Detail

When you are scouting, always be on the look-out for details that say something about your landscape. Often, an isolated detail can say as much, or more, about a place as a wide shot. Details almost always add a personal, intimate feel. Think of this technique as a distillation, boiling down the essence of a scene to one statement—a haiku rather than a narrative poem.

The detail can be anything—the way the wind or water has eroded a rock, the compression lines in the side of a cliff, peeling bark on a tree, a deer's footprint in moss. Just keep your eyes open. When scouting, it may help to sit down on a rock or log. Doing so makes you slow down and pay attention to the little things around you. Think about the character of the scene and what elements in it would best encapsulate it. Then go hunting.

Isolating Key Elements

Once you have thought about and found the details you find compelling, consider light and composition. At what time of day will they be best lit? Is it the shape or the texture of the detail that is so interesting? If it is the shape, you may want to silhouette or partially silhouette the detail against the sky or some other background and photograph it when it is in shadow. If the texture or color is important, you want the item

Tip

When making long exposures, use a remote release to avoid camera movement. If you don't have a remote release, use the camera's self-timer. And be mindful of any breeze that might be moving your subject.

George F. Mobley

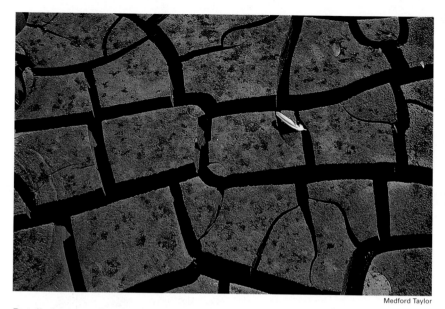

Medford Taylor

Detail photographs reveal the feeling of a place in an intimate way. Think about the character of the place you are photographing, then look for details that reveal it, as in the cracked soil above. In both images, the photographers have used shapes and textures to make graphic images and have employed the rule of thirds in their compositions.

Raymond Gehman

Sam Abell

lit in such a way that these qualities are enhanced—low warm light for the contours of texture, perhaps soft diffuse light for color saturation, for example. You may want to add light with a reflector or flash. Also think about depth of field. You want enough to show the details, but not so much that they blend with the background. Depending upon how close you are and what kind of lens you are using, you may have to use quite a long exposure and a tripod.

If you are particularly interested in small details, you might want to carry a macro lens. When using a macro, be aware that movement problems are greatly exaggerated, and be extra careful. In most cases, fairly small objects can be photographed with normal or short telephoto lenses.

Details don't have to be extreme close-ups. The character of a winter forest is beautifully revealed in this tight shot of a tree trunk and branches.

FOLLOWING PAGES: The still reflection of rising cliffs gives this image of rainwater captured in rocks a graphic impact. On location, look down as well as up and around.

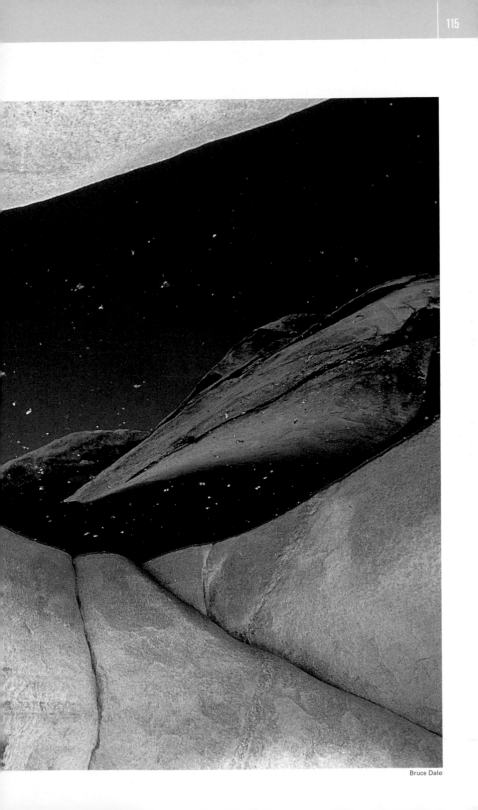

Bruce Dale

Patterns and Blocks of Shape and Color

Nature presents all sorts of patterns and shapes, and using one as part of a composition or even the main subject can make a compelling image. Just as with details, always be on the lookout for patterns when you are scouting or hiking.

Repetition is probably the most easily spotted (and most often photographed) pattern in nature—tree trunks, wind-sculpted ridges on a sand dune, and the like. Think of ways to emphasize the repetition, often by backing off a bit and using a long lens to compress the repeating elements. But that is not the only approach: A wide-angle lens and low angle can also work quite effectively. With ridges on a sand dune, for example, try lying down with a wide-angle lens and having the ridges recede from the camera.

Look through different lenses and move around to find the view that strikes you as the most interesting. If you are shooting near a river or lake, look for the repetition of reflected trees, mountains, or other objects in the water.

Also look for the one element that interrupts a pattern. It might be one tree trunk of a different color, or a protruding rock that breaks the perfect symmetry of concentric circles in the water. These reinforce the pattern by being different. Remember the rule of thirds as you compose images like this—you rarely want the one different element to be in the center of the image. Patterns can be

Blocks of shape and color—yellow trees in the foreground, shadowed forest, and white mountain—give this image impact and depth. Look for patterns not just in details, but on the macro level.

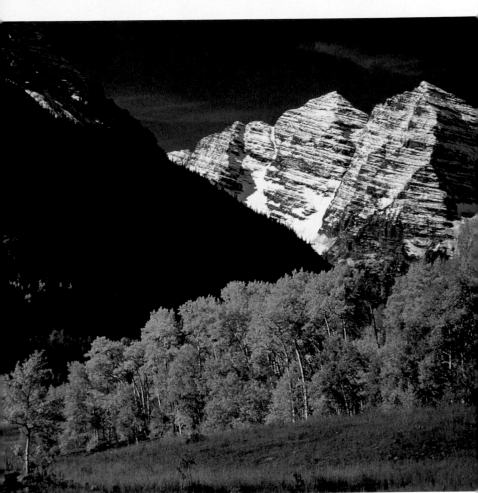

Paul Chesley

either grand or small, so look carefully at the details in everything around you.

Patterns can be less obvious, too: Blocks of color, either the same hue or different ones of about equal tonal value, can enhance and lend depth to an image—a roundish green bush in the foreground, a mossy boulder in the middle distance, and a leafy oak in the background. The repetition of color and shapes will be pleasing and will carry the viewer's eyes into the frame.

Tip

We usually look for detail, so it can be hard to perceive blocks of color or shape. Squint a bit: Details are blurred and you can see things as masses.

Soothed and softened
by wind and weather,
moss-covered rocks
clustered like eggs in a
nest depict an intimate
detail of a riverbed.

Raymond Gehman

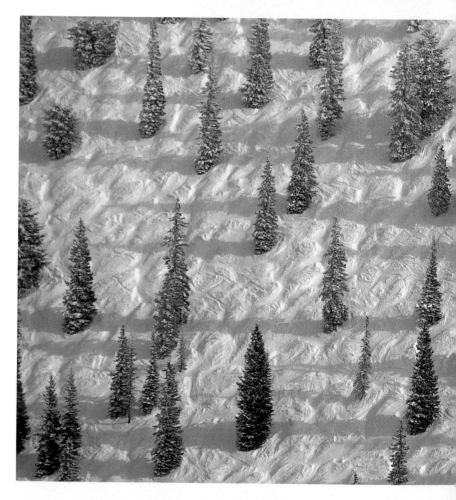

Lines

Besides leading the eye into the frame, lines can be graphic elements. Look for lines you can incorporate into the composition—subtle as well as obvious ones. A horizontal line along the base of a grove separating it from a field might be repeated by another along the trees' crowns. What mood do you want? Horizontal lines usually convey serenity. Vertical ones emphasize power, and diagonal ones imply dynamism.

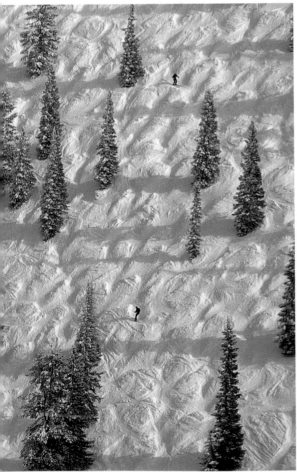

Paul Chesley

The vast pattern of soaring pines against a ski slope creates a graphic image of verticals. The swirls of ski tracks add to the movement and texture of the image, and the skiers on the right add scale.

FOLLOWING PAGES: Composition transforms what could have been a rather ordinary landscape into a dramatic image of thrusting horizontal and vertical shapes. Notice how the top of the frame cuts off the verticals.

William Albert Allard

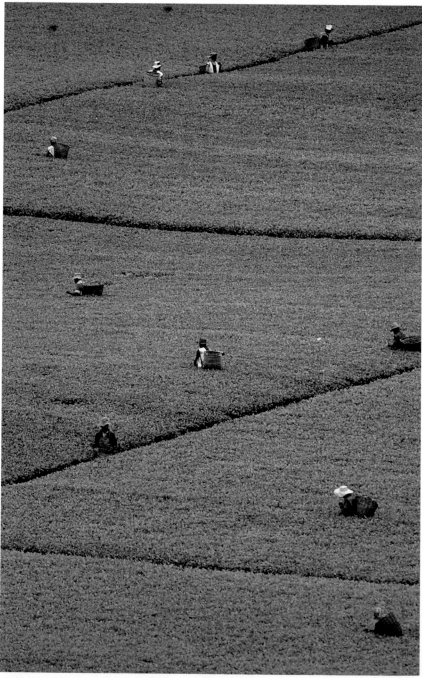

Robert Caputo

Textures

The texture of a subject can reveal a lot about its character and, as the word implies, its feeling. Find ways to emphasize the textures of everything in your frame—rocks, trees, grass, et cetera. If you are shooting a meadow, the textures of the grasses and flowers will give a feeling of what kind of meadow it is. Use texture to convey your personal impressions of the scene.

Textures are usually revealed best by early and late sun—the raking angle makes them stand out by modeling them. Also consider backlight, which can enhance texture. Shooting long grass, a slight blur can create a swath of color, so use a slow shutter speed. Use a fast one to capture detail, and be careful of wind.

Zigzagging lines of a tea field carry our eyes into the frame at left and at the same time divide it into geometric blocks. The pluckers add scale and create a graphic of their own. The close-up of grasses below is pure texture and color. Textures do not have to be small—look for them on a large scale, too.

Todd Gipstein

ADRIEL HEISEY
An Eagle's Eye

ADRIEL HEISEY was captivated by landscape paintings and photographs as a boy, and the first thing he bought with his own money was a camera so that he could try to make them himself. The passion for landscapes stayed with him as he grew up, but he never dreamed he could make a living from landscape photography. He got a pilot's license and a flying job near his Pennsylvania home. Then he visited the American Southwest.

"The land, the people, the geology got into my blood," he says. "It took a few years, but I eventually quit my job in Pennsylvania and moved to Arizona."

In 1985 he got a job as a pilot for the Navajo Tribal Government, making pictures out of the window from his pilot's seat. "I flew all over this incredible landscape, and was getting some decent photographs, but I saw a lot of places I knew would make beautiful images if I had more control over when I was there and how close I could fly. That's when I decided to try to build my own plane."

Most of his spare money went into the project, as well as all his spare time. Every evening

Adriel Heisey (left) built his own plane so he could virtually hang suspended over the landscapes in his beloved Southwest.

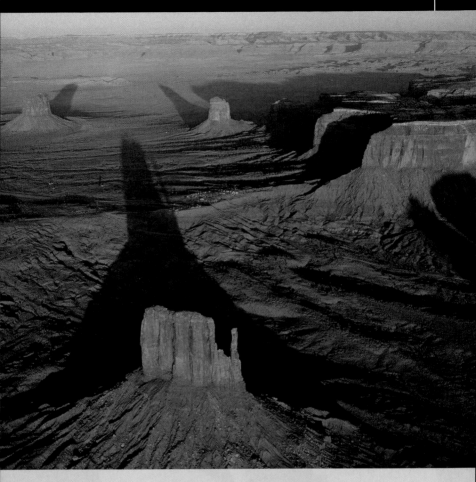

Shooting when the sun was very low, Heisey caught the extremely long and dramatic shadows cast by desert mesas. The shadows also serve as leading lines, carrying our eyes into the picture.

and weekend found him diligently assembling and testing the plane, with occasional breaks for hiking out to places he'd noticed while flying. It took a year and a half, but "it was a perfect way to learn," he says. "I had a stable job that paid for building the plane and for the film—and I got to study the land every day. I had no expectation of being able to make a living by making pictures. I was just doing it because I loved it."

The first audiences for his photographs were Navajo schoolchildren, and their reaction further strengthened Heisey's resolve: "They were so excited to see this different perspective of places they knew very well that they infected me

Low sunlight stream-
ing through a hole in a
rock wall creates an
almost purely graphic
image of light and
dark. Heisey scouts by
plane and on foot to
find locations like this
one, then returns for
the light he wants.

with their joy. It spurred me on to try to get even
better images."

The plane was ready in 1991. It folds up and
can be mounted on a trailer and driven to the
remote locations he wants to shoot. It is slow (he
usually shoots while flying at about 40 miles an
hour) and can fly for only about two hours. He
camps as close to the locations as he can so he
can be up and shooting in early and late light.

"I spent several years learning about the plane
and how to make images from it. The only way
was by experimenting, and I made every mistake
in the book—but how else was I going to figure
it out? To learn about making optimal images, I
tried every film on the market, and pushed all of
them to see how they responded. I wanted to
learn how to translate what I saw onto film, so I
would shoot a place, look at the results, then go
back and try again. I spent more money on film
and processing than I did on the plane."

After three years of serious shooting, Heisey
felt ready to show his work. Encouraged by Sam
Abell and others at the Santa Fe workshops, he
kept experimenting and learning. But he didn't
give up his day job. He needed to pay for that
film. And the job was paying other dividends:

"Flying for the Navajo gave me more than
just an opportunity to explore the land," he
says. "I was privileged to see it through the eyes
of people who have an intimate relationship
with it. From the air it can often look empty and
desolate, but I soon learned that the Navajo
think of it as their backyard—full of energy and
life. They have a great love of their land, and
deep respect. Understanding their feelings about
the land helped my photographic vision."

In late 1995, Heisey left his job and now con-
centrates solely on his photography. The years of
study and experimentation paid off.

The wedge of suburban sprawl slices its way into wilderness. The graphic image works well both as a photograph and as a message.

"One of the most important elements for me now is perseverance. I've been in a few scary spots when the plane has been seriously damaged, and I ask myself, 'do I really want to keep doing this?' But then there are those moments of seeing some feature of the landscape that is so inspiring that I realize that I can't not do this. Even when I fly in a big airliner, I gaze at the land and can't wait to get back out and shoot."

Heisey has no urge to expand his photography beyond the Southwest. "I am oriented to have deep and longstanding relationships with a few places in the region where I live rather than a lot of places all over the country," he explains. "I prefer to explore them photographically over a period of time, to try to capture and communicate their mystery and power. My photographs are the dividends from this kind of long-term commitment."

Heisey's Photo Tips

- Study other peoples' work. Find books of aerial photographs and really pore over them. Pay attention to what moves you, and then analyze the images to figure out why it does.

- Find someone who likes to fly and wants to get more air time. You can share the cost of the plane, and you can shoot while your friend flies.

- If you want to use a gyrostabilizer, try to borrow or rent one before you invest. Spend time practicing on the ground, walking around with it to become familiar with how it works.

- Bracket both exposures and composition. Really work on a place, using different focal length lenses, shooting verticals and horizontals. By doing this I am always discovering new picture ideas I had not thought of. The place will reveal itself to you over time.

- Get to know your gear so well that you don't have to think about it and can concentrate on the subject when shooting.

- Go back to a place again and again and again until you get what you want.

- If you are both piloting and shooting, the simpler the plane the better. And remember that flying always has to come first.

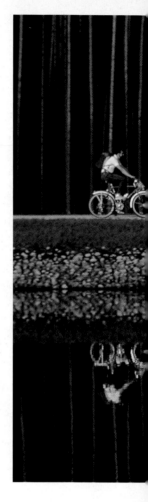

Rivers and Waterfalls

If there is a river or stream in the scene you are shooting, think about the character of it and how to convey that character in the image: A big, slow river should look and feel different from a lively mountain stream. The water can be the center of interest of the image, or you can use it as an element of composition—as a diagonal or other leading line, as a horizontal line, or as a shape that compliments other elements in the frame.

If you are shooting a stream, decide what its most important quality is: Is it the clearness of the water, the speed with which it bounds over rocks, or the beautiful trees overhanging its banks? Compose the frame in a way that accentuates the quality you have decided on, and then choose a combination of shutter speed and aperture that will further enhance it. If you want to show how crystalline the water is, use a fast shutter speed so that the water does not blur— but you also want enough depth of field to have the rocks in the streambed in sharp focus. If it is speed you are after, then you might want to let the water blur in a way that conveys that quality.

Reflections

Look carefully for reflections in the water. Some can be used to enhance the image—say the colors of autumn leaves—but others may be distracting. You may have to move around to include or

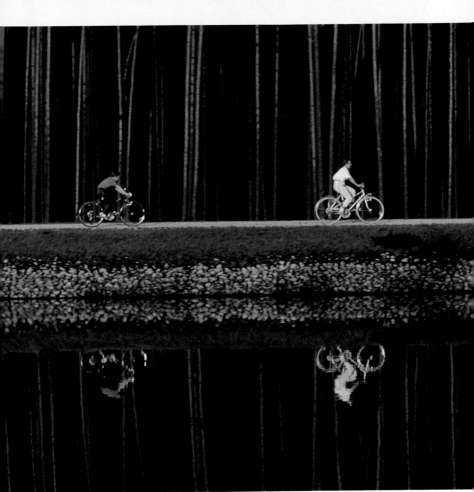

Gerd Ludwig

Richard Olsenius

Reflections can create dramatic backdrops. Above, the photographer used a telephoto to eliminate unwanted elements, then waited for cyclists to enter the frame. The image of grasses is almost purely graphic.

The glare from light bouncing off water, glass, or other highly reflective surfaces can obscure details and cause colors to become desaturated. To eliminate glare, use a polarizing filter, as the photographer of this waterfall has done in the image at the far right. Rotate the polarizer until you see that most or all of the glare has been reduced.

without polarizer

John G. Agnone (both)

eliminate them, or return when the sun is at a different angle. Use a polarizing filter to eliminate some of the reflection and increase contrast; rotate it until you have the effect you want.

Waterfalls

There are two ways to shoot waterfalls: freeze or blur. As with streams and rivers, think about the character of the waterfall and how you want to portray it to determine which approach is the right one.

Freezing

Freezing water as it spills over a fall is usually the best way to communicate its power, espe-

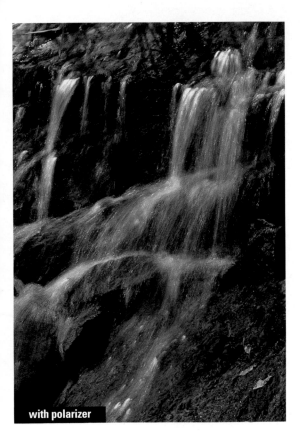

with polarizer

Tip

Avoid getting your equipment wet. If you are shooting near a fall that is sending up a lot of spray, cover your camera with a plastic bag as you would to protect it from rain. If it or a lens gets wet, wipe the item immediately and put it in the sun to dry.

cially of big cascades. To freeze a waterfall, you will need a shutter speed of at least 1/250, faster if it is a raging cataract spraying water and mist. Remember that the higher the shutter speed, the wider the aperture and the less the depth of field. Ensure that everything you want to be sharp is. If you cannot get enough depth of field, try using a wider lens and moving closer.

Blurring

Blurring a waterfall conveys a different feeling from freezing it—the soft, silky white blur of streaming water feels more serene and peaceful. To blur a waterfall, you will need a shutter speed

John Eastcott and Yva Momatiuk

What kind of forest are you shooting, and how can you dramatize its character? Shooting straight up at autumn leaves (above) emphasizes their colors against a blue sky and suggests crisp fall weather. Silhouetting larger tree trunks of a denser forest (right) evokes a brooding and moody note.

of 1/8 or so. Use a tripod or other camera stabilizer and a remote release cord or the camera's self-timer to avoid shaking the body with your finger. If you don't have a tripod with you, try resting the camera on your camera bag, a rock, or something else stable. You probably will not have to worry about depth of field at shutter speeds this slow, but do be aware of any wind that might be shaking trees or bushes that are in the frame.

Forests

When photographing forests, first think about what kind of forest it is, and how you want it to feel in your image. Is it dark and brooding or light and airy? Do you want it to feel somber or

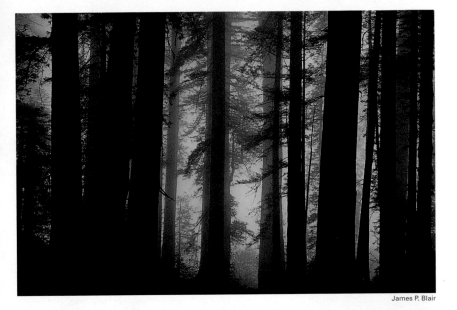

James P. Blair

cheerful? Are there any special features that will tell the viewers how you feel about it?

As with any photograph, find a point of interest. It might be one slightly different tree trunk, a path winding through, or a splash of color on a flowering vine. Whatever it is, compose in such a way to lead the viewer to it. Look for shafts of light penetrating the canopy or one spot on the forest floor that is directly lit by the sun.

Whether you are outside shooting toward a forest or inside the woods, look for patterns, lines, and other compositional elements you can use. Try both wide and telephoto lenses: A wide lens looking up at the trees will make them soar, a telephoto will compress a row of trunks. Lie down and look straight up through the branches; climb a tree to look down a path.

If you shoot a lot of forests, you might want to experiment with different films to see which one you like best. Different types of film reproduce colors differently, and some of them do not make

Tip

Never be content with what you see in the viewfinder the first time you raise it to your eye. Move around, lie down, find a different angle.

FOLLOWING PAGES: Photographing a rain forest usually requires a tripod and consideration. Be careful metering in dark forests such as this, as the meter will want to overexpose all the dark green.

Bruce Dale

Tip

If you don't have a waterproof case, use sealable plastic bags to keep your equipment dry. But don't put hot silica gel in them!

much distinction between close shades of green. Fuji Velvia 50, for example, does a good job of recording subtle differences in greens but is not to some people's taste for other situations. To see what works for you, try several types in the same situation and then compare the results.

If you are camping in a forest that is very humid, be careful that fungus does not invade your gear. The best defense against fungus is silica gel, which is available at many hardware and camera stores. Put your gear and the dry silica

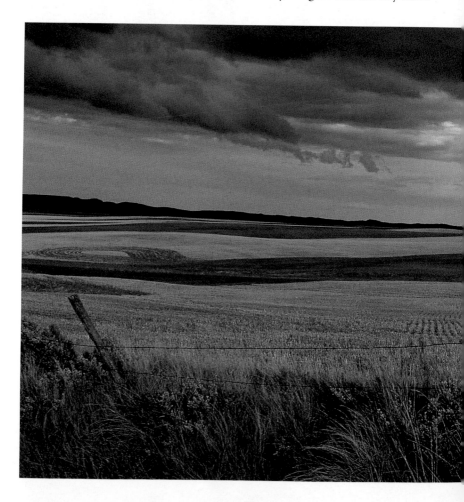

gel in an airtight and waterproof case whenever you are not using it. When the gel turns pink, it is saturated; you should dry it in an oven or in a frying pan over a fire (much as you would make popcorn). When the gel turns blue, it is ready for use.

Plains

Wide-open spaces such as plains and prairies are among the hardest landscapes to photo-

Plains and prairies are about expanse, a difficult concept to photograph. A seemingly low sky, alternating lit and shadowed plains, and the foreground fence, give this scene depth and interest.

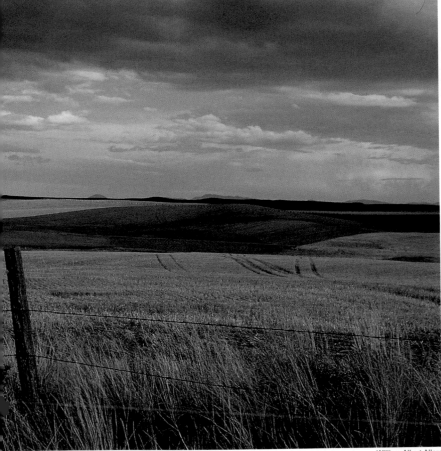

William Albert Allard

graph well because there is often no obvious point of interest. In most cases, the huge scope of the scene is one of the things you are trying to communicate. But remember that viewers need something on which to focus. Look for an element peculiar to that place, and use it as a point of interest that says something about the scene and imparts a sense of scale. You don't want the viewer's eyes to wander aimlessly around the frame, so use whatever might be available to lead him into the image—a winding road or a fence line, for example.

Like every forest, each plain has its own personality, so hunt around until you have found an angle and composition that reflect it. What is the most important feature of this particular place? Think about the sky: Do you want a lot or a little of it? A clear blue sky might best reflect the character of one plain, a brewing storm another. Remember the rule of thirds. If the sky is important, place it along the bottom third division of the frame. If it's not, put it along the upper third.

Deserts

Heat is the main enemy in the desert, for both you and your film. Make sure you have enough water—remember that shooting in a desert is quite different from just going for a stroll there. You will probably be carrying 15 to 20 pounds of gear in your camera bag and often running around to get good frames. It's easy to get dehydrated without realizing it. Try to keep the film cool, or at least prevent it from getting too hot. Heat will alter the color of films, and it can even warp lenses and cause the oil in cameras to get so thin it leaks out. Never leave either your equipment or your film in a closed car in the sun. Always put them in the shade.

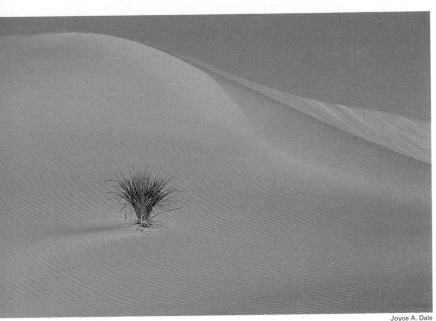

Joyce A. Dale

Deserts are often cold at night, so open all waterproof cases for the night and close them first thing in the morning—they will retain the cool air for quite some time. Take a cooler or Styrofoam box for your film and keep ice in it if possible; remove any film you will need about an hour in advance to allow it to warm up. If you are staying in one spot in a desert, you can bury film in the sand to keep it cool. Be sure to dig a deep enough hole—and don't forget where it is.

Sand and dust seem to love to get inside equipment, especially when it's windy. Both will scratch your film, and sand will wreak havoc inside the focusing rings of your lenses. Protect your gear by carrying it inside your camera bag, pack, or case when you aren't using it. If it's really dusty, use plastic freezer bags. Change film out of the wind if you can, and every time you open your camera, clean the inside with a camel hair brush or shots of

The green of a lone plant lends stark contrast to the empty expanse of sand in this desert scene. The photographer used the sweep of the dune to frame the plant and applied the rule of thirds in composing the landscape.

air from a squeeze bulb. When you change lenses, give the rear element and the inside of the camera a few blasts from the bulb. Clean all your equipment every night with the brush and the bulb. Take care when cleaning the lenses that no sand has gotten on the tissue or cloth.

In the middle of the day, look for waves caused by the heat. By using a long lens to compress them, you will get very dramatic shots that really say "hot." Deserts are great places for pictures of the stars. There is no humidity, and usually no terrestrial lights interfere, so stars seem more numerous and are unusually brilliant. Watch the way the color of the sand changes throughout the day with the angle of the sun. Again, think about the particular characteristics of the desert and how best to capture them. A wide shot might best portray one desert, while a lone plant struggling to survive on the side of a dune might best connote another. Think about including the sun in your shot.

A single shell implies the serenity of an empty beach. Shooting the scene at twilight gives it a much different feeling than doing so in bright sunlight. In shots such as this, which use an important element in the foreground, be conscious of depth of field. Check it with the preview button if your camera has one.

Sea Coasts

Consider these different scenes: A tranquil tropic isle, with turquoise water lapping at the white sandy beach; storm waves pounding on a rocky New England shore; a deserted cove; a densely packed vacation spot. What kind of ocean shore are you photographing, and how can you best convey what it is all about? What time of day, what kind of weather, and what season is most appropriate for capturing its character? These are the kinds of questions you need to ask yourself as you scout for the right vantage point and composition before you start shooting. Each shoreline is different. Show it in your images.

Once you have thought about the character of the shore, look for elements you can use to

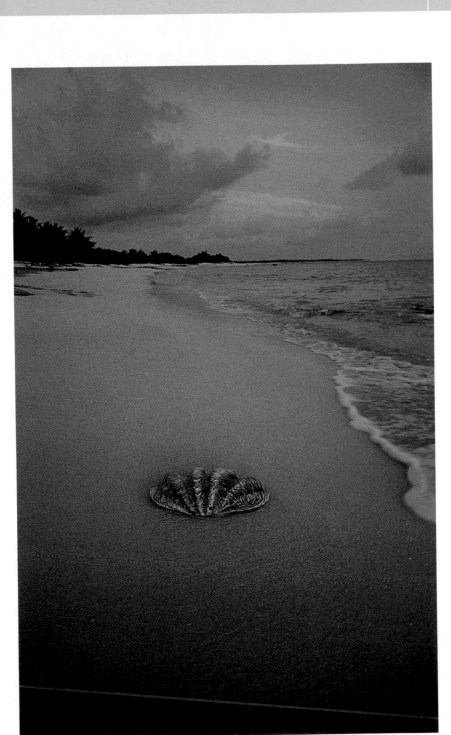

William R. Curtsinger

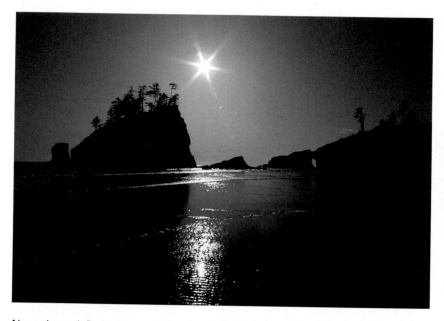

Never be satisfied with your first shot. After making an interesting image of the sun setting behind rocky promontories, the photographer noticed as he walked around that he could position himself so that the sun would set through the small hole in the rock. Keep exploring situations as you shoot.

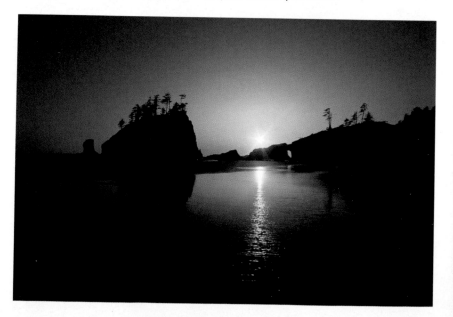

reinforce the feeling. The tropical beach might best be framed by palm trees. The rocky shore might be most dramatic if it includes a huge spray of water rising from the rocks. A crowded beach might best be shot with a telephoto that stacks the people lying in the sun.

As in the desert, be careful about sand. Especially if it's windy, protect your camera and lenses, and don't open the camera back unless you are in a well sheltered area.

Mountains

Hiking is always a compromise between having all the gear you want and determining the amount you want to carry. If you can drive into the mountains, or if you are on an expedition with porters or mules and aren't too concerned about weight, pack the gear in foam rubber inside a waterproof case—most of them come with inserts that you can adapt. The foam rubber absorbs most of the inevitable jostles and

Tip

If you drop your camera into salt water, rinse it several times in fresh water and keep it immersed to prevent air from oxidizing the metal until you can get it to a camera-repair expert.

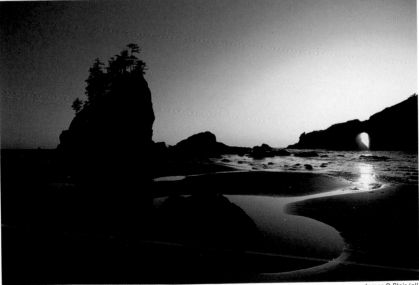

James P. Blair (all)

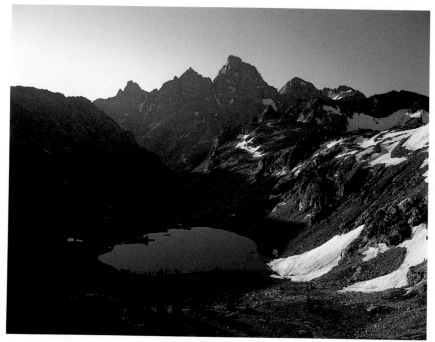

James P. Blair

Mountains, particularly snow-covered ones, can be tricky to photograph because the scene often contains areas of deep shadow. Be careful metering; you don't want to blow out the white of the snow, but you want to be able to see some detail in the shadows.

bumps, and the case will protect your gear from dust as well as rain or snow. The case can be tied onto a pack frame to make it easier to carry. But keep at least one camera and lens out and handy for pictures along the way.

If you are hiking, though, you probably want to keep your gear to a minimum. A wide-angle and short telephoto are usually enough lenses. Even better are short (20 to 35mm) and long (80 to 200mm) zoom lenses. Keep whatever gear you use most around your neck or in a pocket for easy access. Put the rest in plastic bags, set them in the middle of your backpack, and surround them with clothes to protect them from jolts.

If you are shooting in winter or above the snow line, try to keep your gear reasonably warm at all times. As mentioned in the section about shooting in the snow, the severe cold is

hard on batteries, the oil that lubricates cameras, and film. Keep the camera inside your jacket, taking it out only to actually shoot, and keep extra film in an inside pocket so the leader doesn't turn brittle and snap off. Take plenty of extra batteries—they don't last long in the cold. Remember that bare skin sticks to metal when it's really cold, so you might want to put tape over parts of your camera.

What feeling do the mountains you are shooting give you? Are they rugged or gentle, threatening or enchanting? Look for elements that will reinforce your feeling and convey it to the viewer. What composition, angle, light, and weather are most appropriate? And be on the lookout for telling details—they can reflect the spirit of the mountains, too.

Aerials

Aerial pictures are an important part of many National Geographic stories because there is often nothing else that conveys the expanse and geography of the place being covered as well as a good aerial view. Aerials put places in context and frequently let us see something familiar in a way we never have before. But aerials can be tricky, in large part because you are usually moving when you make them.

Think of aerial landscape pictures in the same way you think of normal ones. Be mindful of good light and composition. Aerials need to be just as well composed, using the same techniques of the rule of thirds, leading lines, and so forth. Patterns are especially revealing from the air, whether they are the rectangles of agricultural fields or the symmetry of sand dunes.

You can make aerials from commercial airliners, though it is difficult because you must shoot

Tip

Unless you absolutely have to, avoid rewinding the film in severe cold. The extremely low humidity promotes static electricity that can appear on the film as lightning bolts. If you must change film, rewind it slowly to reduce the risk of static.

Tip

Ask the plane char-
ter company if any
of their pilots have
experience with
aerial photography.
A good pilot can
make all the differ-
ence, as he or she
will more easily
understand what
you are after and be
able to maneuver
you into position.

through a (usually dirty and scratched) window, and you have no control over where the plane flies. If you are shooting from a big plane, try to find a seat with a clean window that is forward of the wings and exhaust from the engines. A rubber lens hood is useful; it will not transmit the vibrations of the plane and will cut out reflections in the window. Note that the windows in planes are plastic. If you shoot through them using a polarizing filter, your shots may have weird rainbow patterns. All aerials need to be made with a fast shutter speed, generally 1/250 or faster, though how fast depends on altitude. You can get away with a slower shutter speed if you are quite high. Your best chances will be on ascent and descent, though if you are flying over some huge feature of the land, like a range of mountains, you should be able to get good images from cruising altitude.

The best aerials are made from something that flies slow and low—a single-engine plane, a helicopter, an ultralight—even a blimp. They allow you to get just the altitude and angle you want, and you can fly at a time of day that has the light you are after. The best planes are single-engine overhead wing ones, such as the Cessna 206. These craft can fly quite slowly, and most of them have removable doors, usually the rear passenger ones. Sitting in the back with the doors removed, you will have a wide view—just be mindful of the wing struts and the wheels.

Don't let the charter company tell you they can't take the door off a helicopter or single-engine plane. They can, and you will be greatly served by the wide and unencumbered view. Strap yourself in securely, keep the camera straps around your neck, and put your gear on the floor in front of you. The wind is powerful, so lean into the plane to change film or lenses.

The sweep of the rock wall rises from the plain in the aerial above. Below, the ridge serves as leading line, carrying the eye to the very back of the frame. Bracket compositions as well as exposures as you explore a subject.

Melissa Farlow (both)

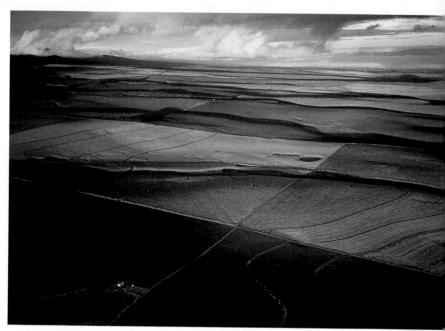

Robert Caputo

Getting up early pays off, as in this aerial image made when the rising sun bounced off the clouds to paint the landscape with gorgeous light. The buildings at lower left give the image scale.

It's best to have a talk with the pilot before you take off. Tell him what you want to photograph, from what angle, and from what altitude. It often helps to make a drawing to give him a visual representation of where you want the plane to be. You should make several passes, because you only have a brief time to shoot on each one as you circle over the subject. Use a motor drive to get off as many shots as you can on each pass. In a helicopter you can hover once you've found the perfect spot, but be aware that hovering produces a lot of vibration.

Be careful of exposure. Aerial views of landscapes can often fool the meter in the camera if they are predominantly of a forest (which will make the camera overexpose), a desert (which will make it underexpose), or some other dark or bright subject. Think about the tonal quality of the scene, and adjust your exposure accord-

ingly. You want to use slow film for the fine grain and color rendition, but you need to use a fast shutter speed of at least 1/250, faster if you are using a telephoto. Planes and helicopters have more vibration than you realize, and you don't want it to affect the image.

If you can't remove the door, ask if you can open or take off the window—the copilot's window is usually openable in small planes. If that fails, clean the window where you will be sitting inside and out before takeoff; be sure to use a nonabrasive cloth to avoid scratching it. Remember that the windows are usually plastic and that using a polarizing filter may result in images with rainbow patterns. Shoot as you would through the window of a big plane.

The Human Presence

We have focused on natural landscapes, but sometimes it is impossible to avoid reminders of the human presence—and this is not always a bad thing. The lone farmhouse on the prairie used as an example in an earlier chapter is one example of how the presence of man can add to an image. Other examples are roads, fences, et cetera, used as leading lines. Sometimes including a man-made object can reinforce the feeling of your image, or be used to help its composition. Think of Ansel Adams's "Moonrise, Hernandez, NM," in which the serenity of the scene is enhanced by a little settlement. At other times, man-made objects can augment the image by introducing contrast. If a landscape you want to photograph contains man-made objects, look for ways to incorporate them. The types of structures people have made often say a lot about a place—an old windmill in a field, a weathered cabin in the woods, for example.

Tip

Work out a system of hand signals with the pilot if you are flying in a small plane. It will be too noisy to talk, but you need a way to indicate that you want to be higher or lower, closer or farther away.

FOLLOWING PAGES: Man and his works can enhance some landscape images. In this case, the photographer found the composition he wanted, then waited for a car to pass to complete it.

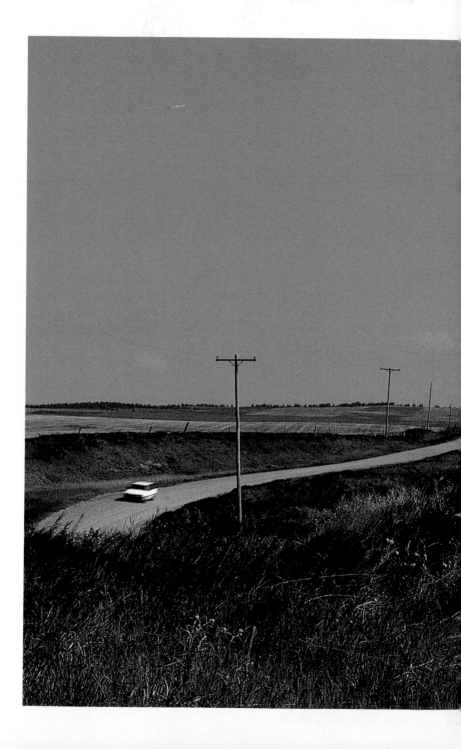

William Albert Allard

EQUIPMENT

Camera Bag Essentials

camera bag lined with foam rubber
 compartments
camera body with body cap and neck strap
favorite lenses with lens caps
lens hoods
handheld exposure meter
film of various ISO ratings or digital cards
 for digital cameras
air blower brush
lens cleaner solution and lens tissue wipes
tripod, monopod, and/or bean bags
gaffer's tape
electronic flash
extra camera, exposure meter,
 and flash batteries
remote release
equipment manuals

Options

filters such as UV haze, skylight 1A, polar-
 izing, neutral density, graded neutral
 density, light amber, light blue
plastic bag or sheet to protect equipment
 in wet weather
soft absorbent towel or chamois
silica gel for wet weather
large umbrella
cooler and freezable gel packs
 for hot weather
extra camera body
extra electronic flash
extra handheld exposure meter
selenium cell exposure meter that operates
 in cold weather
notebook and permanent marker
self-stick labels to identify film
sunglasses
head and wrist sweat bands
camouflage clothing when shooting
 landscapes with animals
18% gray card
resealable plastic bags for storing film
customized diopter to match your
 eyeglass prescription
reflectors
slave units and radio transmitter for
 electronic flash

extension tubes
teleconverters
film x-ray bag for air travel

Tool Kit

film changing bag
film leader retriever
Swiss army knife
filter wrench
small socket wrenches
jeweler's screwdrivers
tweezers
needle-nosed pliers to loosen jammed
 tripod joints
pencil eraser to clean connections

Safety Kit

flashlight
compass
whistle
water
snacks
first aid kit
reflective tape for clothing during
 nighttime shooting

WEB SITES

The World Wide Web provides an almost limitless resource for landscape photographers, with sites for individual photographers, books, discussion groups, travel and weather information, scenic attractions, photographic equipment, how-to tips, and much more. Sometimes the information can be quite specific: If you are interested in shooting the fall colors in New Hampshire, for example, the state Web site (www.newhampshire.com) will tell you when and where they are peaking. Use a search engine to find sites by photographer's name or keyword. The following is a partial list to get you started. Keep in mind that site content can change or even vanish. There's no substitute for hunting around.

General

Adriel Heisey
 http://www.AdrielHeisey.com
American Society of Media Photographers

http://www.asmp.org
BestStuff.com
http://www.beststuff.com
Bruce Dale
http://www.BruceDale.com
Eastman Kodak Co.
http://www.kodak.com
North American Nature Photography
Association
http://www.nanpa.org
National Audubon Society
http://www.audubon.org
National Geographic Society
http://www.nationalgeographic.com
National Wildlife Federation
http://www.nwf.org
National Wildlife Refuge System
http://bluegoose.arw.r9.fws.gov/
Robert Caputo
http://RobertCaputo.com

Photo Books and Magazines Online
BOOKS:
Amazon
http://www.amazon.com
Barnes and Noble
http://www.barnesandnoble.com
Buy.Com
http://www.us.buy.com/retail

MAGAZINES:
Apogee On-Line Photo magazine
http://www.apogeephoto.com
Camera Arts magazine
http://www.cameraarts.com
E-Digital Photo magazine
http://www.edigitalphoto.com
Image Soup Magazine
http://www.netcontrol.net/themata-a/9x2
Outdoor Photographer magazine
http://www.outdoorphotographer.com
PC Photo magazine
http://www.pcphotomag.com
Photo District News magazine
http://www.pdn-pix.com
PHOTO LIFE magazine (Canada)
http://www.photolife.com
PhotoPoint magazine
http://www.photopoint.com/photo
talk/magazine

Popular Photography magazine
On AOL only; keyword: POP PHOTO
Shutterbug magazine
http://www.shutterbug.net

Photo Travel Guides and Tourism Online
Fodor's Focus on Travel Photography
http://www.fodors.com
GORP: Great Outdoor Recreational Pages
and Links (includes U.S. National Parks &
Preserves by state) http://www.gorp.com
Great Outdoor Recreation Pages, Canada
(links to numerous federal and provincial
sites) http://www.gorp.com/gorp/location/
canada/canada.htm
National Park Service
http://www.nps.gov
National Parks/type in specific name
http://www.nps.gov/parks.htm
National Scenic Rivers
http://www.nps.gov/rivers/
National Scenic Trails
http://www.nps.gov/trails
Outdoor and Travel Photographers
ResourcesCenter http://members.
aol.com/natureloco/index.html
Parks Canada
http://www.parkscanada.pch.gc.ca
PhotoSecret's Links to Photo and Travel Sites
(also called Travel Guides for Travel Pho-
tography) http://www.photosecrets.com
Photo Traveler
http://www.phototravel.com
Photograph America newsletter
http://www.photographamerica.com
Professional Photographers of America
(PPA) http://www.ppa-world.org
State Tourism Information
http://www.statename.com
Tourism Canada
http://www.tourism-canada.com
Trail maps from National Geographic
http://www.trailsillustrated.com
Travel Canada
http://www.canadatourism.com
Travel Photography
http://www.travel-library.com
US Department of State
http://www.state.gov/
USDA Forest Service National Headquarters

http://www.fs.fed.us/
US Fish and Wildlife Service Home Page
http://www.fws.gov
US Photo Site Database/By State
http://www.viewcamera.com
Weather Channel
http://www.weather.com

Recreational Photography Forums

AOL Photography Forums (on AOL only;
keyword: Photography (on AOL:
rec.photo.technique.nature.com)
CompuServe Photography Forums
(on Compuserve: "go photoforum")
Shaw Guides to Photo Tours and Workshops
http://www.shawguides.com

PHOTOGRAPHY MAGAZINES AND BOOKS

Magazines

Listed are photography magazines. Look,
too, at travel, scientific, and cultural ones to
see how other photographers have covered
a place. Most magazines have Web sites.

American Photo. Bimonthly publication
with features on professional photographers, photography innovations, and
equipment reviews.
Camera Arts. Bimonthly magazine including portfolios, interviews, and equipment
reviews.
Digital Camera. Bimonthly publication
emphasizing digital cameras, imaging
software, and accessories.
Digital Photographer. Quarterly publication
emphasizing digital cameras, accessories,
and technique.
Nature Photographer. Quarterly magazine
about nature photography.
Nature's Best Photography. Quarterly magazine showcasing nature photography and
profiling top professional photographers.
Outdoor Photographer. Ten issues per year.
Covers all aspects of photography outdoors, with articles about professional
photographers, equipment, technique.
Outdoor & Nature Photography. Four issues
a year. Heavily technique and equipment

oriented with a strong how-to approach.
PC Photo. Bimonthly publication covering
all facets of computers and photography.
Petersen's PHOTOgraphic. Monthly publication covering all facets of photography.
Photo District News. Monthly business
magazine for professional photographers.
Photo Life. Bimonthly publication with
limited availability in the U.S. Covers all
facets of photography.
Photo Techniques. Monthly magazine dedicated to equipment, film, and darkroom
coverage.
PhotoWorld Magazine. Bimonthly publication dedicated to shooting, composition,
lighting, processing, and printing.
Popular Photography. Monthly publication
covering all facets of imaging from conventional photography to digital. Heavily
equipment oriented, with comprehensive
test reports.
Shutterbug. Monthly publication covering all
facets of photography from conventional
to digital. Also includes numerous ads for
used and collectible photo equipment.
View Camera. Bimonthly magazine covering
all aspects of large-format photography.

Books

The following are books about photographic techniques, composition, and the
like. Also look at books of landscape photographs and paintings, too numerous to
list here but which you will find in any
good bookstore or online.

General Photography Books
Debbie Cohen, *Kodak Professional Photoguide,* Tiffen.
Derek Doeffinger, *The Art of Seeing,* Kodak
Workshop Series, Tiffen.
Eastman Kodak Co., *Kodak Guide to 35mm
Photography,* Tiffen.
Eastman Kodak Co., *Kodak Pocket Photoguide,* Tiffen.
Lee Frost, *The Question-and-Answer Guide
to Photo Techniques,* David & Charles.
Tom Grimm and Michele Grimm, *The
Basic Book of Photography,* 4th ed., Plume.
John Hedgecoe, *The Art of Colour Photography,* Butterwork-Heinemann.

from Lepp & Associates on digital photography.

Digital Photographer. Quarterly publication about digital cameras and accessories.

Digital Photo Pro. Bimonthly magazine about how professional photographers work digitally.

F8 and Be There. Photo newsletter about outdoor and travel photography.

The Natural Image. Quarterly publication from Lepp & Associates on nature photography.

Nature Photographer. Quarterly publication about nature photography.

Nature's Best. Quarterly magazine showcasing nature photography.

Outdoor Photographer. Monthly (11 issues) magazine covering all aspects of nature and outdoor photography.

PCPhoto. Monthly (9 issues) publication about digital photography.

Petersen's PhotoGraphic. Monthly general photography magazine.

Photo District News. Monthly publication about professional photography.

Photo Life. Bimonthly Canadian photography magazine.

Popular Photography & Imaging. Monthly general photography magazine.

Shutterbug. Monthly general photography magazine.

Photography Books

Ansel Adams, *Examples, the Making of 40 Photographs,* Little, Brown

Ansel Adams, *The Print,* Little, Brown

Theresa Airey, *Creative Digital Printmaking,* Amphoto

William Albert Allard, *Portraits of America,* National Geographic Books

Leah Bendavid-Val, Sam Abell – *The Photographic Life,* Rizzoli

Niall Benvie, *The Art of Nature Photography,* Amphoto

David Blatner, Bruce Fraser, *Real World Photoshop 7,* Peachpit Press

Peter K. Burian and Robert Caputo, *National Geographic Photography Field Guide,* National Geographic Society

Michael Busselle, *Creative Digital Photography,* Amphoto

John Paul Capognigro, *Adobe Photoshop Master Class,* Adobe Press

Robert Caputo, *National Geographic Photography Field Guide: People & Portraits,* National Geographic Society

Robert Caputo, *National Geographic Photography Field Guide: Landscapes,* National Geographic Society

Jack Davis, *The Photoshop 7 WOW! Book,* Peachpit Press

William Cheung, *Landscapes – Camera Craft,* Sterling

Elliot Erwitt, *Snaps,* Phaidon

Joe Farace, *Digital Imaging: Tips, Tools and Techniques for Photographers,* Focal Press

Tim Fitzharris, *National Park Photography,* AAA Publishing

Bill Fortney, *Great Photography Workshop,* Northword Publishing

Barry Haynes, Wendy Crumpler, *Photoshop 7 Artistry,* New Riders

John Hedgecoe, many books, one of the best how-to photo authors

Craig Hoeshern, Christopher Dahl, *Photoshop Elements for Windows and Macintosh,* Peachpit Press

Chris Johns, *Wild at Heart,* National Geographic Books

Eastman Kodak Co., *Kodak Guide to 35mm Photography,* Sterling

Scott Kelby, *The Photoshop Book for Digital Photographers,* New Riders

Scott Kelby, *Photoshop 7 Down and Dirty Tricks,* New Riders

Steve McCurry, *Portraits,* Phaidon

Joe Meehan, *The Photographer's Guide to Using Filters,* Amphoto

Gordon Parks, *Half Past Autumn,* Bullfinch

B. Moose Peterson, *The D1 Generation,* Moose Press

Rick Sammon, *Rick Sammon's Complete Guide to Digital Imaging,* W.W. Norton

John Shaw, many books, superb nature photography how-to

Rob Sheppard, *Basic Scanning Guide for Photographers,* Amherst Media

Rob Sheppard, *The Epson Complete Guide to Digital Printing,* Lark Books

James L. Stanfield, *Eye of the Beholder,* National Geographic Society

National Geographic Photography Field Guide Digital

Rob Sheppard

Published by the National Geographic Society

John M. Fahey, Jr., *President and Chief Executive Officer*

Gilbert M. Grosvenor, *Chairman of the Board*

Nina D. Hoffman, *Executive Vice President*

Prepared by the Book Division

Kevin Mulroy, *Vice President and Editor-in-Chief*

Charles Kogod, *Illustrations Director*

Marianne R. Koszorus, *Design Director*

Staff for this Book

Charles Kogod, *Editor*

Carolinda E. Averitt, *Text Editor*

Cinda Rose, *Art Director*

Kay Hankins, *Designer*

Michelle Harris, *Researcher*

Bob Shell, *Technical Consultant*

R. Gary Colbert, *Production Director*

Lewis Bassford, *Production Project Manager*

Meredith C. Wilcox, *Illustrations Assistant*

Mark Wentling, *Indexer*

Manufacturing and Quality Control

Christopher A. Liedel, *Chief Financial Officer*

Phillip L. Schlosser, *Financial Analyst*

John T. Dunn, *Technical Director*

Alan Kerr, *Manager*

One of the world's largest nonprofit scientific and educational organizations, the National Geographic Society was founded in 1888 "for the increase and diffusion of geographic knowledge." Fulfilling this mission, the Society educates and inspires millions every day through its magazines, books, television programs, videos, maps and atlases, research grants, the National Geographic Bee, teacher workshops, and innovative classroom materials.

The Society is supported through membership dues, charitable gifts, and income from the sale of its educational products. This support is vital to National Geographic's mission to increase global understanding and promote conservation of our planet through exploration, research, and education.

For more information, please call 1-800-NGS LINE (647-5463) or write to the following address:

National Geographic Society
1145 17th Street N.W.
Washington, D.C. 20036-4688 U.S.A.

Visit the Society's Web site at
www.nationalgeographic.com.

Library of Congress Cataloging-in-Publication Data
Sheppard, Rob
 National Geographic photography field guide: digital : secrets to making great pictures / text and photographs by Rob Sheppard.
 p. cm.
 ISBN 0-7922-61887
 1. Photography--Digital techniques. I. National Geographic Society (U.S.) II. Title.
TR267.S535 2003
775--dc22 2003059340

FRONT COVER: Although it is composed of pixels, rather than grain, this digital image is very much a true photograph.

Bruce Dale